HOW TO DRAW
MANGA
Computones

Vol. 1

CD-ROM Serial No.
CTWM30-300444-079

HOW TO DRAW MANGA:
Computones Vol. 1
by Senno Knife

Copyright © 2005 Senno Knife
Copyright © 2005 Graphic-sha Publishing Co., Ltd.

This book was first designed and published in 2005 by Graphic-sha Publishing Co., Ltd.
Sansou Kudan Bldg., 4th Floor, 1-14-17 Kudan-kita, Chiyoda-ku, Tokyo 102-0073, Japan.

Original cover design and text page layout: Shinichi Ishioka
English translation management: Língua fránca, Inc. (an3y-skmt@asahi-net.or.jp)
Planning editor: Masahiko Satake (Graphic-sha Publishing Co., Ltd.)
Publishing coordinator: Michiko Yasu (Graphic-sha Publishing Co., Ltd.)
Project management: Kumiko Sakamoto (Graphic-sha Publishing Co., Ltd.)

First printing: April 2005

Collaborating Artists:	Rutoto Nekoi Yashito Hitsujino
Cover Illustrator:	Kiwi Onogawa
Color Coordinator:	Junya Hasegawa
Special thanks to:	Yutaka Murakami (M Create Co., Ltd.)

ISBN: 4-7661-1471-X
Printed and bound in China by Everbest Printing Co., Ltd.

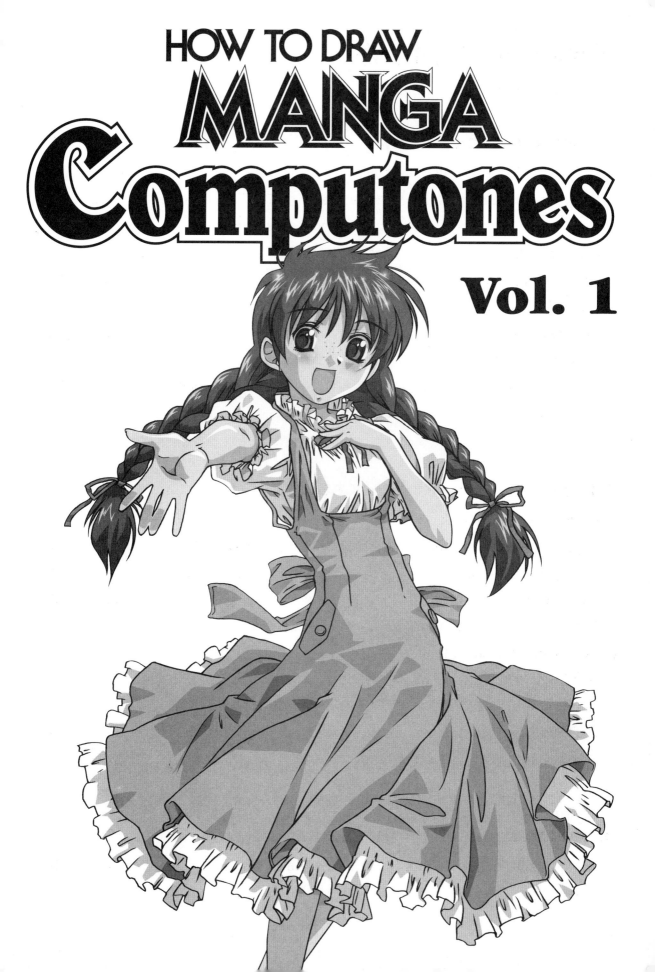

Table of Contents

Chapter 4: Manual

In order to use the included tone patterns CD-ROM, you must have at least one of the following software packages installed:
Adobe Photoshop 5.0/5.5/6.0/7.0/CS or Adobe Photoshop LE 5.0; Adobe Photoshop Elements 1.0/2.0; Jasc Paint Shop Pro 7.0/8.0
Please use the CD-ROM after you have installed one of the above.

Use Tones to Enhance Your Manga!!!

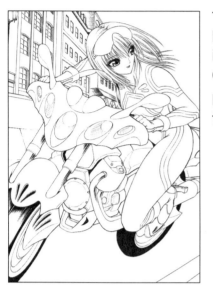

Tones are the secret to making your manga look more like the pro's. In the world of B&W manga, tones are indispensable for adding realism. No manga is complete without them.

Let's take a look at some examples of how effective tones work to enhance illustrations.

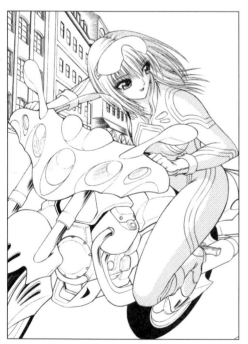

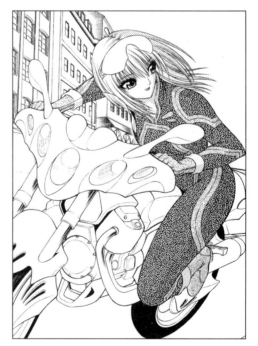

Example 1:
Applying a tone to the character

First, apply a tone to the character's skin. By applying tones, expressions become neater and livelier.

Example 2:
Applying a tone to the clothing

Then, apply a tone to the leather overalls. Tones can express not only the shading but also the texture of leather.

You can turn out work just as cool as this using tones!!

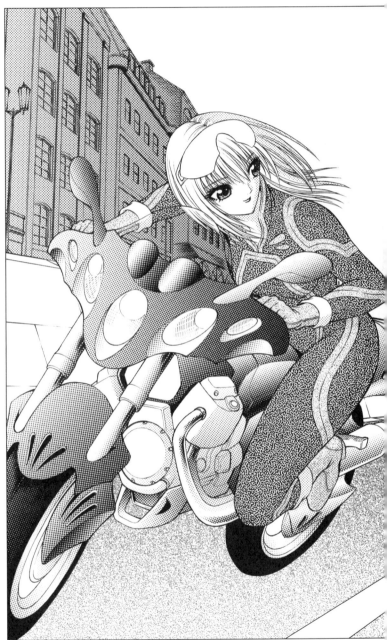

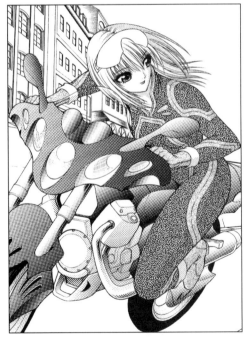

Example 3:
Applying a tone to the motorcycle

Tones are necessary for girls on bikes, too. Tones can even make a metallic finish look shiny.

Example 4:
Applying a tone to the background

Lastly, apply a gradational tone to the building, and a dither gradational tone to the street. This makes the background look more real.

How many tones can you pick out in the picture below? Here is a pro toning job!!

Even the most casually drawn frame of manga has some tones used in it.
Try to find out just how many tones are really used in this professional illustration.
Bet you'll be surprised. The answer's at the bottom.

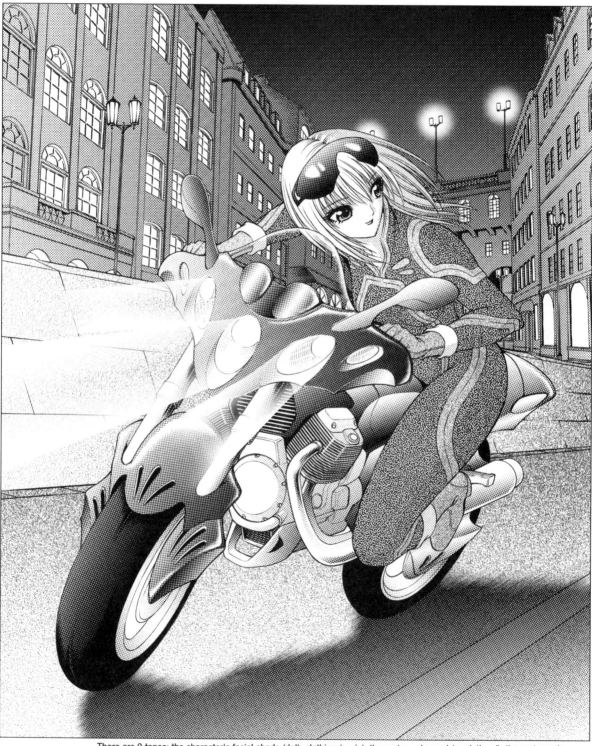

There are 9 tones: the character's facial shade (dot), clothing (grain), the motorcycle cowl (gradational), the motorcycle engine (dot), the motorcycle's shadow (gradational), the background sky (gradational), the background buildings (gradational), the background walls (dither gradational), and the background street (dither gradational).

Chapter 1

Tone Basics

Dot Tones: The Most Fundamental of All Tones

Creating different shadow effects is the basic use of a dot tone.

Of all the different tones, dot tones are used the most. From characters to buildings, dot tones are used for all kinds of expression. For strictly B&W manga, they are indispensably important tools for creative expression.

#61 tone

Tones are a collection of dots.

The collection of dots outlining this girl is a dot tone. By applying a tone to the face, its shadowing effect creates a more of a 3-D look. The dot tone used here is #61, and it is the most common of all tones.

The names of each tone mean something.

There are a few different types of dot tones, and they have code numbers that depend on the size and density of the dots. Try to remember the nomenclature.

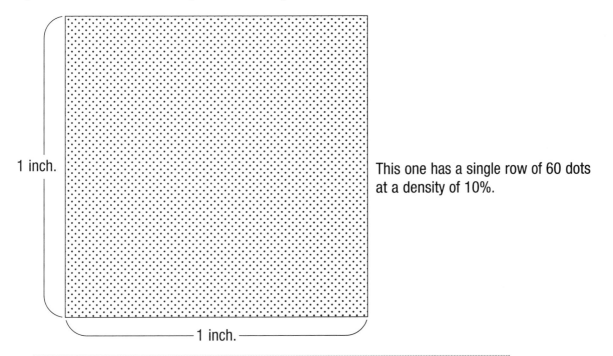

1 inch.

1 inch.

This one has a single row of 60 dots at a density of 10%.

The number refers to how many dots in a single row there are per square inch (25.4 mm). In this case, there are 60 lines per inch (LPI) in this tone. In lines with a high LPI, each dot is that much smaller, and a low LPI means each dot is that much bigger. So, the number also indicates dot size.

Low LPI, big dots ← → High LPI, small dots

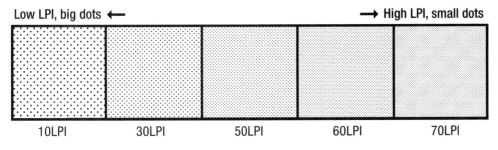

| 10LPI | 30LPI | 50LPI | 60LPI | 70LPI |

The percentage expresses the dot's lightness or darkness—in other words, its density. A high percentage indicates a dark color, while a low one indicates a light color. 0% is completely white, and 100% is absolute pitch black.

Light color ← → Dark color

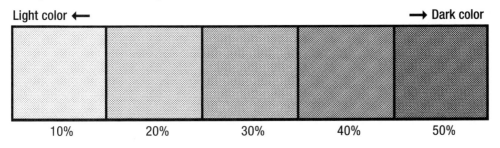

| 10% | 20% | 30% | 40% | 50% |

The first digit of the LPI and the first digit of the density combine to form the tone's code number. So a 60 LPI tone at 10% density is called #61.

Trying Out and Seeing the Differences between Dot Tone Finishes.

A shadow finish changes along with the LPI.

Even with two dot tones in the same density, they will leave different impressions with different LPI. Generally, the lower the LPI the artier a dot seems, while the higher it goes the more precise and minute it appears. For shading manga characters, the dots should be big but not so much that they stand out. They should come out clearly, without destroying the shadow effects after printing. Using a 50 to 60 LPI tone is normal.

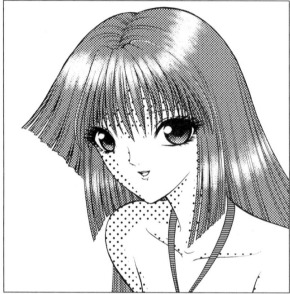

This one is a 20 LPI at 10%
Here, the dots stand out more than the lines, obscuring the expression.

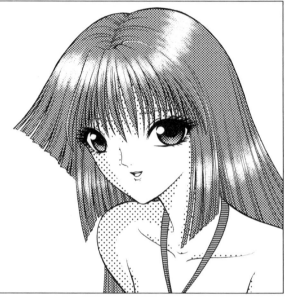

This one is 40 LPI at 10%
The dots come out clearly, but not so much that they obscure anything.

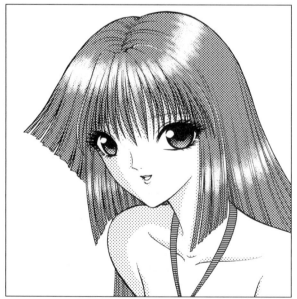

This one is 60 LPI at 10%
The dots here don't stand out at all. The shadow looks natural.

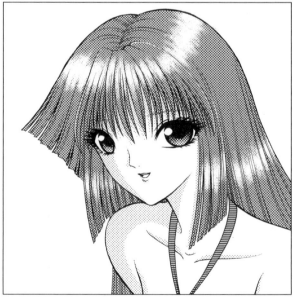

This one is 70 LPI at 10%
This looks more natural, but the dots are so small that they might become invisible when printed.

A dot tone with a skin shading density

A dot's color density is important, too. Think carefully about how light hits something. Except scenes with very bright light, a dot tone for human skin ranging from 5 to 20% density is common. If it is too dense, then the shadow stands out so much and the character does not look good.

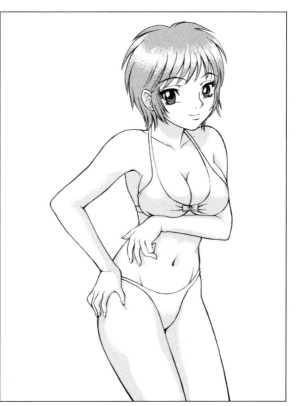

60 LPI, 10%
This is a typical shading density. This is just right for expressing a character's depth.

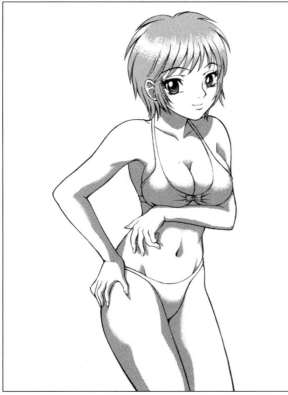

60 LPI, 30%
This one is a dark shadow. This might be something used for a character in very bright sunlight.

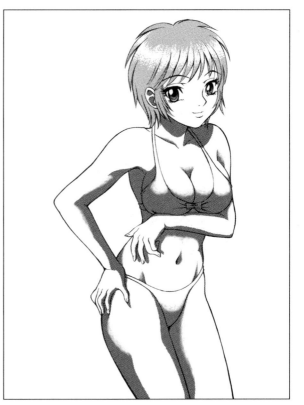

60 LPI, 50%
There is too much of a difference between the light and dark parts of the character's skin. It looks unnatural.

Expressing Depth and Texture with a Gradational Tone

Give the building a feeling of width and depth.

In all cases of anything being hit with light, the closer side is lighter, and the further side is darker. In cases like that, gradational tones come in handy. By using these tones, which change gradually from black to white, it's simple to add depth to a line drawing.

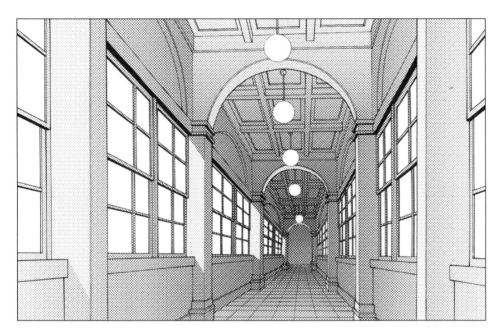

This is a building interior in the early afternoon. The center is darkest.
Applying a lighter tone to the top, bottom, left, and right brings out the depth.

Emphasizing darkness

Instead of a gradually changing gradational tone, for an outdoor scene in the dead of night or a pitch-black room, there are ways to use abrupt changes to create the mood. This is more impressive than simply painting everything black.

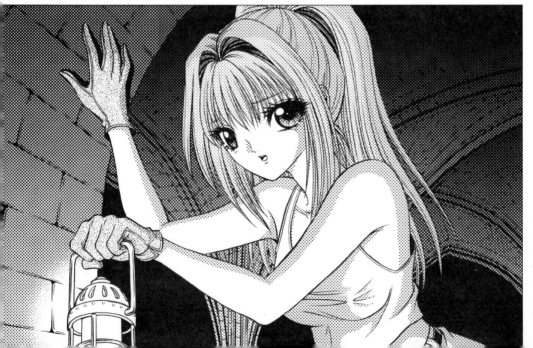

In the back on the right, by using a gradational tone slightly darker than the one on the wall closest to the lantern, the room feels darker.

Using a gradational tone for curvy skin textures

Gradational tones don't merely make building feel nearer or further away. As a shading technique, they can be used to bring out the curves and shadows on human skin. Keep the direction of the light in mind and use them where the shadows lie.

More so than by using dot tones, gradational tones can bring out deeper, richer shadows on the body or clothing.

Expressing shimmering materials such as lasers, plastic, etc.

Gradational tones are great for shiny, darkish materials. To create mood, applying etched gradational tones for wrinkles, slack, or bumps on clothing is more effective.

For shiny, black materials, use the dark part of the gradational tone a bit more.

COLUMN

Gradational tones can easily bring out the depth of small, cylindrical items, like cans or pipes.

Expressing Backgrounds with Special Effects

Create an entire scene with one background image.

Special effect tones are mostly generated with computers and are one of the most popular tones. Differing from dot tones, they are typically constructed from a single, complete image. By choosing a tone to match the character, it is possible to achieve psychological descriptions, such as happiness or seriousness.

If they don't get in the way, try using special effect tones with focus lines or speed lines. Focus lines serve to draw the reader's eye toward their center.

A playful mood

A light, breezy tone can make a girl seem cute.

Feeling worn-out

Try creating a mood as if some strange magic were at work in the marble.

A deeply moved feeling

By using a flowing, shifting background, create an emotional, pulsating image.

Effective Digital Toning

Uses of Lightning-patterned Tone: From Backdrops to Speech Balloons

When using special effects tone, adjusting the size of the pattern enables you to produce a wide host of special effects. Lightning-patterned tone is frequently used to portray emotionally "shocking" moments. Adjusting the size of the pattern allows you to create different dramatic effects for similar scenes.

Utilizing the shape of the original pattern to add jagged flashes of light to the background allows you to portray strong emotional bursts, such as surprise, confusion, or anger.

Drastically enlarging a single bolt of lightning and positioning it behind a character allows you to portray the moment a thought flashes through his or her mind.

Writing characters' lines inside of a lightning bolt dramatizes the mood projected by the lines spoken.

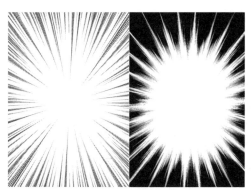

Regular burst effects and radiating line effects can be used in the same way as these special effects patterns.

OK. I got it!

Other Popular Digital Tone

Knowing How to Use the Different Types of Digital Tone

Dot and gradation tone are the most common types of digital tone patterns. However, other popular basic tone patterns do exist. Try to use the different patterns effectively according to their particular attributes.

Dot Patterns

Like standard dot tone, sand tone consists of repeating dots; however, sand tone allows for greater subtleties than a simple dot pattern.

Sand Tone

Use this to suggest matte finishes or rough textures.

Common Uses of Sand Tone
- Ground
- Bricks
- Stone finishes

Hatching

Use this to create a rougher, coarser look than that of sand tone.

Common Uses of Hatching
- Asphalt
- Weathered wood
- Engine

Lines

These are used to suggest stiffer, more uniform textures than you would use for hatched or sand tone. Note: lined tone does produce a flat, two-dimensional look.

Common Uses of Lines
- Clothing fabrics of uniform hues
- Metallic walls
- Blackboards

Herringbone

Herringbone creates a softer uniform look than lined tone.

Common Uses of Herringbone
- Clothing patterns
- Walls and floors

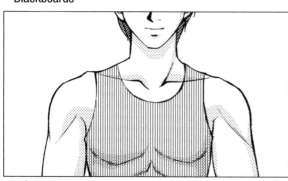

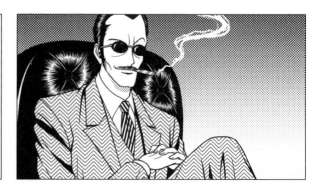

Other Digital Tone Patterns

Line Patterns

Use to suggest fast speeds

Used as a background, line patterns can be used to suggest strong wind gusts, such as in typhoons or squalls. Added to a panel with figures or cars imparts a sense of moment.

Special Effects Tone

Portrayal of Flames and Other Special Effects

The flames seen here are one example

For example, adding flames to the back of a building portrays an actual fire. Added behind a figure and then etched suggests an emotional state, such as anger or fury.

Patterned Tone

Use patterned tone as clothing or fabric patterns, or in backgrounds.

Tones with pictorial designs or repeating patterns are used as clothing or wallpaper print, or as backdrops to describe a character's psychological state.

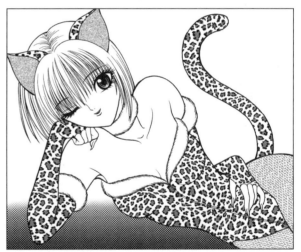

COLUMN

Take care with how patterned tone is juxtaposed.

Avoid juxtaposing patterned tone with digital tone of a similar shade. This will call objects' or figures' silhouettes to become muddled and indistinct.

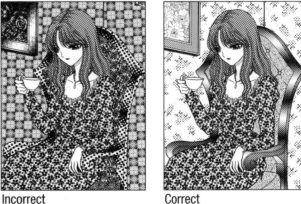

Incorrect Correct

Getting Prepared

Do you have a computer and suitable graphic software?

Photoshop or other such graphic software is a must for digital toning. To handle this software, your computer will need a certain degree of capacity or functionality. Check to see that your computer will be compatible with graphic software.

Minimum Requirements:

Once you have confirmed that your computer is installed with graphic software, install Computones.

• **Windows**
CPU: Pentium III 500MHz or faster
Memory: 256MB or greater
OS: Windows98, ME, SE, 2000, NT, XP

• **Graphic Software (Need One of the Following)**
Photoshop versions 5.0 to 7.0 or CS
Photoshop Elements 1.0 to 2.0
PaintShop Pro 7.0 to 8.0

Handy Peripherals

Scanner	Pen Tablet	Printer

This allows you to scan manga you have drawn on paper into your computer.

This device, which feels the same as a regular pen, allows for more detailed work than a mouse. This item is vital for "etching" tone.

This allows you to print out your finished manga and bind your own books. The printer is also useful for creating test prints.

Try using Computones!

Preliminary check! Are your PC and graphics applications ready to go?

In order to use Computones, you of course need a PC. However, if you have not installed any of the major graphics applications (such as Photoshop), then you cannot use it. Install Computones after you have made sure the graphics application you are using is compatible. The installation process is explained in detail in the manual, starting on page 122.

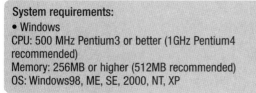

System requirements:
• Windows
CPU: 500 MHz Pentium3 or better (1GHz Pentium4 recommended)
Memory: 256MB or higher (512MB recommended)
OS: Windows98, ME, SE, 2000, NT, XP

• Graphics Applications (one of the following)
Photoshop 5.0/5.5/6.0/7.0/CS
Photoshop Elements 1.0 to 2.0
Paint Shop PRO 7.0/8.0

❶ Draw your illustration directly on your PC or scan one in.

Point: Whichever method you use, make the actual size of your image 600 dpi or 300 dpi and set the color mode to grayscale.

❷ Open your image with a graphics application.

Point: You open a file by choosing File > Open... and selecting a file.

❸ Select the area to which you want to apply a tone.

Point: Use the Magic Wand from the Tool Palette to select an area for your tone, such as hair or the lower neck. If that selects too much of your image, then go back and do it by hand with the Lasso Tool. By holding down the Shift key you can freely select as many areas as you like.

• We will introduce a technique for deft area selection on the next page.

❹ Start up Computones and apply a tone.

Point: Once you have selected an area, click on Filter > Computones in Photoshop, Photoshop Elements, or Paint Shop PRO to start Computones.

By clicking on whichever tone you like from among those displayed in the album on the right side of your screen, you can see what your image would look like with the tone applied. If you like what you see, then click OK to return to your graphics application.

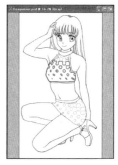

❺ Save your image.

Point: Save your image after you have finished applying tones to all the areas that need it. If you save your image in the PSD format, which can save your image data as it is while you are working on it, then you can easily modify it later. You might change to another format after consulting with a printing company later on.

Tone Application Fundamentals and Area Selection Techniques

By using the Magic Wand Tool, Computones can easily apply a tone to your image. However, if there are any breaks in your main lines, then whatever area is bound outside those lines will be selected, and the tone will not be applied properly. So, let's learn some techniques for easy, discrete tone application.

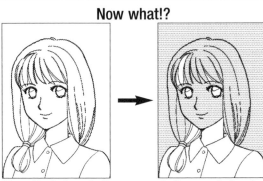

Now what!?

Since the hair main lines are not all connected, using the Magic Wand selects everything all the way in to the background.

Get used to using layers and applying tones.

1. Once you have opened your line drawing in your graphics application, duplicate Background layer to add a new layer (Fig. ❶). Call this new layer "Layer 1."

• How to duplicate a layer:
In Photoshop or Paint Shop Pro, open the Layers palette by selecting Window → Layers, click the button in the upper right to open a menu, and select "Duplicate Layer" (Fig. ❷).

2. On Layer 1, draw a line connecting all the hair lines together where their main lines end (Fig. ❸). This will close them off. Use the Magic Wand to select them (Fig. ❹).

3. Add a new layer, and call this one Layer 2 (Fig. ❺, Fig. ❻).

Go back to Layer 1 and copy the hair section. Move back to Layer 2 and paste the hair section you copied earlier (Fig. ❼).

How to make a new layer:
In Photoshop or Paint Shop Pro, open the Layers palette by selecting Window → Layers, click the button in the upper right to open a menu, and select "New Layer."

4. Now call up Computones for the first time, and apply any tone you like (Fig. ❽, Fig. ❾). The hair tone is now complete. Delete Layer 1, where you drew your guidelines, and you are done (Fig. ❿). The main lines now return to their former appearance, and you have neatly applied your tone. Now save your work as is.
Later, we might consider any alterations. To save the file as a normal EPS or JPEG file, you must "flatten" the layers you have added.

To do this, click on the button in the upper right corner of the Layer palette and select "Flatten Image" from the menu.

Point
By supplementing the lines on a copy and not tampering with the original image, there can be no accidental erasures or tone overapplications on it.

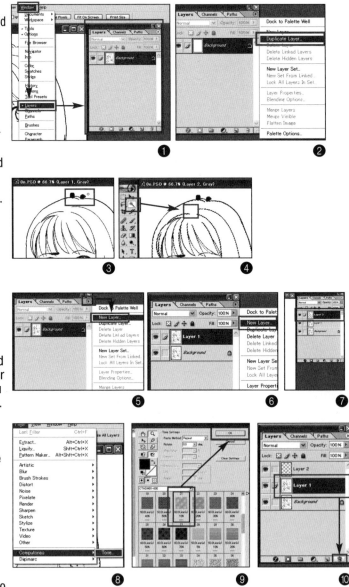

Applying shadow tones

Even when applying shadow tones to the cheek (or really, to any area with no lines), you still have to draw some lines to specify where the tone will be applied. But how do you get rid of those guidelines when you are done? Erase them little by little with the Eraser Tool? Going to such lengths is not necessary. Instead, you can use the techniques introduced previously to simply remove them.

1. Once you've opened the original image, duplicate the Background layer by selecting "Duplicate Layer" from the Layers Palette (Fig. ❶) and call it Layer 1. On Layer 1, draw guidelines with the Pen Tool around where you want your shadows to go (Fig. ❷). Then just as before, use the Magic Wand to select those areas.

2. Add a new layer, and call this one Layer 2 (Fig. ❸). Go back to Layer 1 and copy the shadows you have selected. Once you have moved to Layer 2, paste the shadow sections you copied earlier (Fig. ❹).

3. Call up Computones once again (Fig. ❺), and apply any tone you like (Fig. ❻). The shadows are now complete.

4. Delete Layer 1, where you drew your guidelines, and you are done (Fig. ❼). The main lines now return to their former appearance, and you have neatly applied your tone.

Point

Adding guidelines to a copy lets you work without tampering with the original. Also, since you only copy the areas of the face that needed cheek shadowing, you save time that would otherwise be spent erasing unnecessary lines..

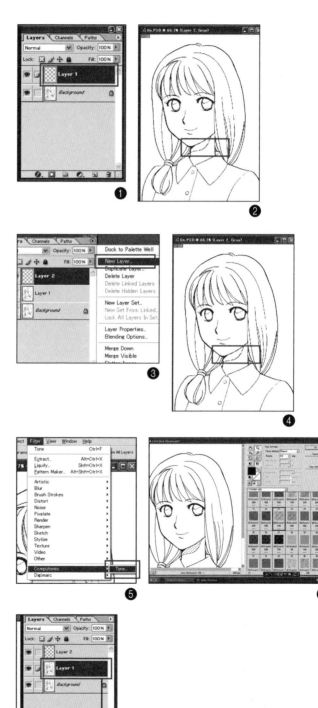

Printing Original Drafts and Creating Books

Bringing Your Artwork to a Commercial Printer vs. Making It Yourself Printing

Regardless of whether you publish your work online or as a hardcopy, you still need to do preparatory work. You could produce a simple book using your own printer, or you could obtain a professional-quality print job, by taking it to your local commercial printer. Since you did spend all that work adding digital tone, take the effort to ensure the final product will look fantastic.

Bringing Your Artwork to a Commercial Printer

Your may either bring your artwork in a digital format to the printers or produce a clean print yourself, and bring it as a hardcopy. It should be noted that the printing process will change depending on whether you have formatted your digital tone using grayscale or black and white.

Printing at Home

Familiarize yourself with the particular characteristics of your home printer. You will need to take care to match the resolution level of the artwork to that of the printer, or a moire effect could result, or the printout could be darker or lighter from that appearing on your monitor. The trick is to purchase high quality printing paper suitable to the artwork's resolution level.

Chapter 2

Tone Applications

Using Digital Tone to Suggest Color

Using Digital Tone to Suggest Black and White

Basically, manga is composed solely of white and black fill. However, using digital tone allows you to create the illusion of color. Yellow, light green, pink, light blue, and other pastel colors require light tone. Furthermore, dark tones are typically used to suggest red, blue, and other hues projecting a distinct, concentrated feel. The following is a table of colors and the approximate density needed. The apparent value and darkness of the color will vary depending on the density [darkness] of the tone.

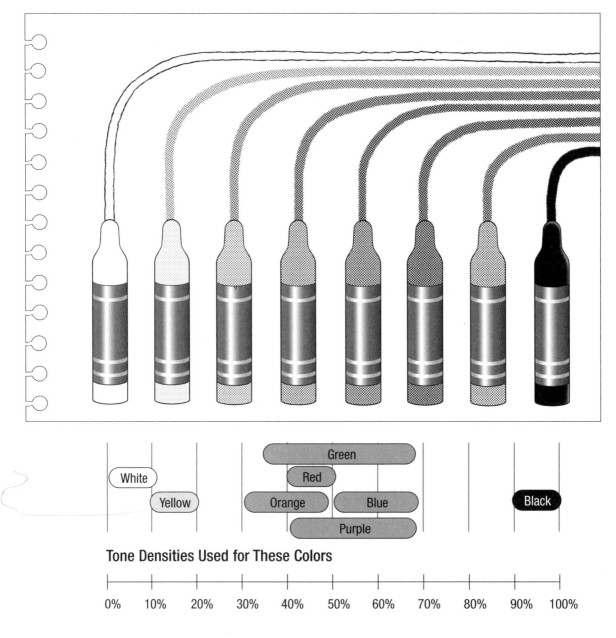

Tone Densities Used for These Colors

0% 10% 20% 30% 40% 50% 60% 70% 80% 90% 100%

Point: Colors consist of variations in hue (e.g. "blue" vs. "red") and shade (e.g. light blue vs. dark blue). While this is actually quite complex, for our discussion, we shall assume "color" to mean "hue."

Using Digital Toning to Suggest Different Colors

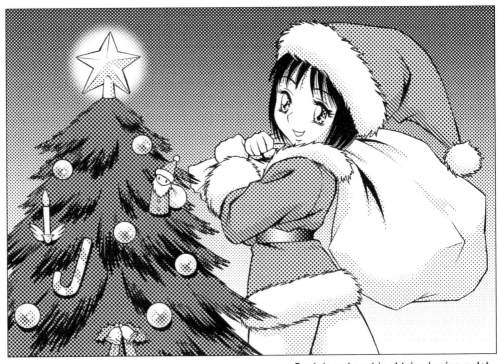

Santa's red coat is obtained using a dot tone at 30%. The tree is a dark green, requiring a 40% to 50% dot tone. The star and moon ornaments are gold, produced using dot tone at 10% to 20%. Glossy areas touched by light were etched to make them appear brighter.

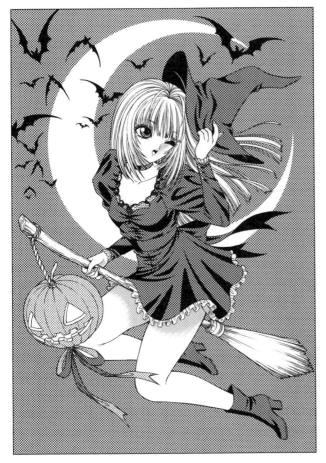

In contrast, grayscale allows you to produce halftones ranging from black to white. When etching, you can use the pen's pressure to produce scaled halftones of gray, working your way to white, rather than automatically producing white.

Digital Tone Used for Shading Gives 2-D Manga a 3-D Look

Be aware of light when shading.

By setting up and defining where light and shadows fall, a line drawing of a two-dimensional character or object takes on a solid appearance. Shadows may also be rendered using black fill. However, using digital tone for shading allows for more convincing portrayal. The brightness of light and the light source's position affect shadows. Picture how shadows are formed, looking at the cubic boxes below.

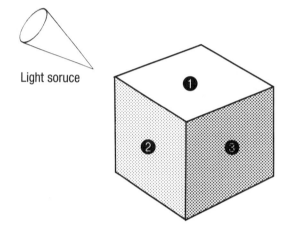

Light soruce

❶ When the light source is from an overhead angle, the light primarily touches upper surfaces. Because these areas should appear light, avoid using tone.

❷ Light from the source does not directly fall on these areas, but rather is reflected, bathing these surfaces in a gentle light. Use a light, 10% tone.

❸ These surfaces are not touched by light from the source, rendering them dark. Use a dark 30% tone to give the box a three-dimensional look.

The light's brightness affects the shadow's tint.

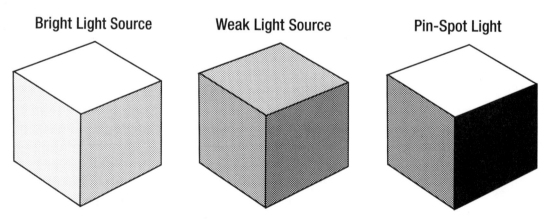

Bright Light Source **Weak Light Source** **Pin-Spot Light**

The light source's brightness affects the shadows formed. Bright light creates greater contrasts in the darkness of the shadows. A weak light source requires that a slightly light tone be used for surfaces touched by light, while dark tones are used for the rest of the subject. For extremely bright lights, such as a pin-spot light, make those surfaces touched by light perfectly white, and other surfaces where shadow falls, use dark tones to create a high contrast.

Characters' Faces and Shading .

Shadows that form on a character's face are more complicated than those on a box. This is due to the curved surfaces of the human body. Let's learn how the brightness and position of the light source affect the shadows while we gain an accurate grasp of where shadows form on a figure drawn at a 10° front angle, the most common view used in manga.

Top Light
This is an extremely uncommon lighting angle, allowing for dark shadows to form in the sunken areas of the eyes and under the mouth and nose. Use it for high-tension scenes.

Light from Below
Shadows form on the top of the nose, in the sunken areas of the eyes, the upper part of the lips, etc. Such a light source is rarely used, but it does make for a striking scene.

Backlighting
The majority of the subject is cloaked in shadow, and highlights appear only around the silhouette. Add strong highlights on protruding or raised surfaces, such as the top of the cheeks and the jaw line.

Figure:
Light Source from the Right
Shadows form on the figure's left. The cheeks are raised surfaces, so light touches them.

Figure:
Light Source from the Left
Because light touches the bridge of the nose on the left, a triangular shadow forms on the nose's right.

Shadows on the Figure

Use shading to emphasize aspects of the figure.

The position of the light source does affect how shadows form on the body. Still, shadows will form in valleys and dimples at the joints and on the muscles. Add digital tone to strategic spots in order to portray a female figure's soft flesh. For a male figure, boldly add tone to the muscles themselves.

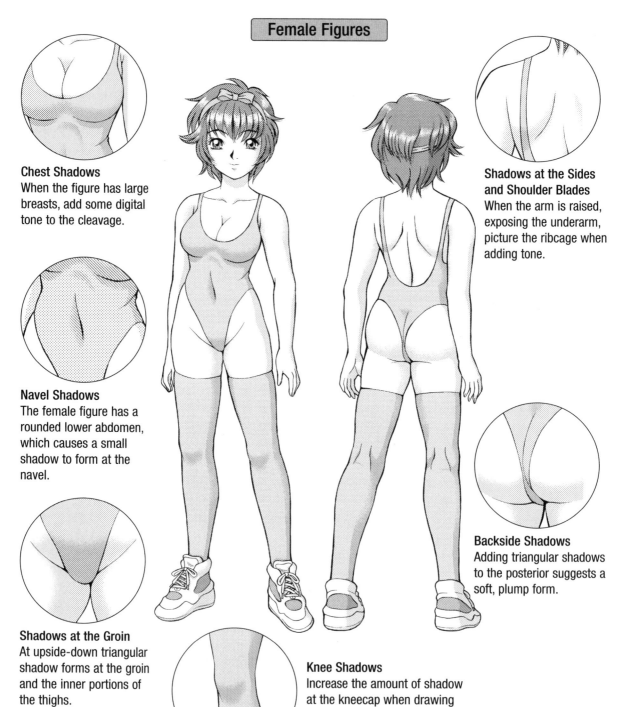

Female Figures

Chest Shadows
When the figure has large breasts, add some digital tone to the cleavage.

Navel Shadows
The female figure has a rounded lower abdomen, which causes a small shadow to form at the navel.

Shadows at the Groin
At upside-down triangular shadow forms at the groin and the inner portions of the thighs.

Shadows at the Sides and Shoulder Blades
When the arm is raised, exposing the underarm, picture the ribcage when adding tone.

Backside Shadows
Adding triangular shadows to the posterior suggests a soft, plump form.

Knee Shadows
Increase the amount of shadow at the kneecap when drawing sports, athletic, or martial arts characters.

Side, Shoulder Blade, and Deltoid Muscles
Use more shading than you would on a female figure, following the respective contours. Use more expansive tone. You may consider drawing diagonal lines in pen and then overlapping the lines with tone.

Abdominal Muscle Shadows
To accentuate the stomach muscles, add digital tone along where the muscles are cut, having the tone taper from top to bottom.

Groin Shadows
Differing slightly from that of a female figure, shadows on the male figure form an upside-down triangle with the bottom [what normally would be the apex] of the triangle rounded.

Knee Shadows
Emphasize the kneecap more than you would on a female figure to suggest a protruding knee.

Backside Muscle Shadows
Because men tend to be more muscular than women, emphasize depressions in the buttocks when adding tone.

Layering Tone to Heighten a Three-Dimensional Feel

Techniques in Layering to Enhance Shadows

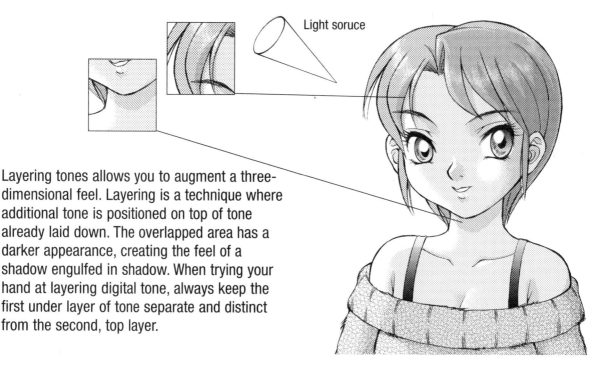

Light soruce

Layering tones allows you to augment a three-dimensional feel. Layering is a technique where additional tone is positioned on top of tone already laid down. The overlapped area has a darker appearance, creating the feel of a shadow engulfed in shadow. When trying your hand at layering digital tone, always keep the first under layer of tone separate and distinct from the second, top layer.

When Layering Tone Is Preferable to Using Multiple Types of Dot Tone

Incorrect

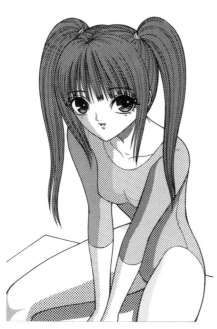

Combining multiple dot tone densities and line counts results in a higgledy-piggledy patchwork look, making the image feel disordered.

Correct

First, add dot tone to the target shadow area. Next, overlap, placing a second layer of dot tone over each spot where a darker shadow is desired. Now the image is more distinct.

Layered Dot Tones to Create Subtle Depth

Effective use of layering lies in shifting dot tones. Shifting the second layer of tone over the first by not overlapping the two perfectly produces a shadow subtly darker than with just one layer. As you increase the degree the exposure of the dots of both tones, the layered areas darken. If the two tones are shifted so that no dot overlaps, and the tones are perfectly doubled, the amount of white decreases, approaching the darkness of a black fill.

1/3 Overlap

This style of overlap has the feel of one extremely pale shadow present within another. Use it to suggest shallow depths.

1/2 Overlap

Here, one shadow is clearly present within another. This technique allows for the suggestion of greater depths.

Full Double

Dark shadows have approximately twice the density of pale shadows. In the case of layered tone, the overlapped areas appear to be cloaked in even more shadow than those with single layers, allowing for more defined shadow portrayal.

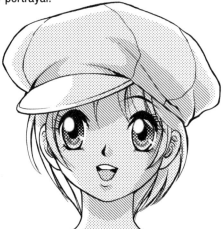

> ## Tip!
>
> ### Overlapping with Dot and Gradation Tone
>
> Different varieties of tones, such as dot and gradation, may also be layered. It should be noted, however, that if the line numbers do not match, then a moire pattern tends to appear when printed, corrupting the image.

The Basics of Tone Etching

Increase the power of a tone 100 times by etching it!

Shading makes a flat image look 3-D, and etching can make those shadows even more effective. Shadows bring out a feeling of depth in an illustration. Further shaping up the areas that don't need shadows by etching them out, a character begins to really feel like it's coming alive, right off the page.

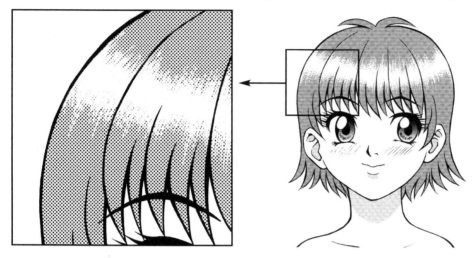

Etching hair tones makes them look more natural. It also makes the hair look alive, light and flowing.

Etch that tone gently.

With a little careful etching, by looking at the before and after images, the difference is instantly visible. Halfheartedly etching something just makes it look messy, but doing it carefully makes a character come alive.

An example of bad etching

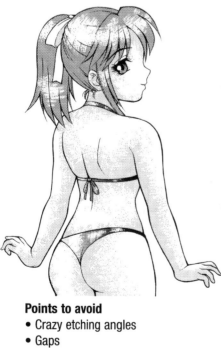

Points to avoid
- Crazy etching angles
- Gaps
- Etching direction mismatched with the dimensions in the image

An example of skillful etching

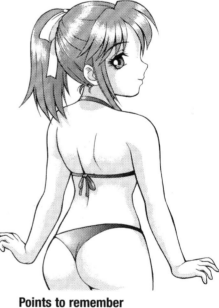

Points to remember
- Natural etching angles
- Follow the lines
- Match the etching direction with the dimensions in the image

Key Points in Etching Tone

Point 1

Etch at approximately a 30° angle.

Dots are spaced a regular, even intervals vertically, horizontally, and diagonally. Consequently, there are angles from which you can etch the tone successfully, and angles, which will make the etching, look sloppy. In particular, etching from precisely 45° will often make the etching appear sloppy, so I recommend avoiding it. If you have etched the tone with unsuccessful results, try gradually modifying the angle of the etching.

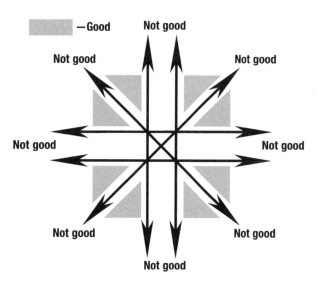

Point 2

Maintain a distinction between etching curved lines and etching straight lines.

The human form is a solid with depth formed by its curved lines. Therefore, maintaining awareness of these curved lines when etching tone will allow you to enhance the sense of three-dimensionality. When etching on flat surfaces, it is critical that you space lines drawn with a pen evenly and draw them perfectly straight.

Gloss on Straight Hair Etching

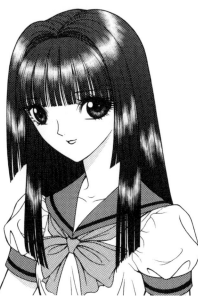

The sheen follows the flow of the locks.

Gloss on Wavy Hair Etching

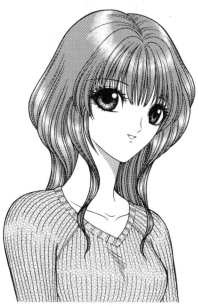

Etch at a curve to give the waves a sense of volume.

Stroke Etching

This technique consists of creating fine, scratch-like strokes on the tone and is the most common form of tone etching used. Repeatedly etching at approximately a 30° angle, which tends to produce the cleanest etches, will allow you to produce a natural sheen to suggest areas touched by light.

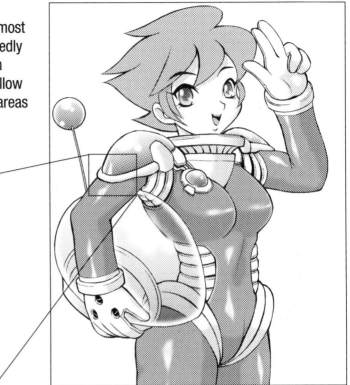

Uniform dot tone can be given depth by adding primarily fine, etched lines and gloss. Use this technique to mimic light sparks as well.

Stroke Etching Used According to the Material Portrayed

Tree Leaf

Wall Corner

Cat Fur

By maintaining awareness of the subject's shape and flow, you will be able to portray the texture as well as add shading. The key is to be conscious of the veins in a leaf or of the fur on a cat and follow them when etching. In order to bring out the roughness in the materials forming a wall, be bold and etch the tone at random, creating hatch-like strokes.

How to Etch with Strokes
For Photoshop 4.0/5.0/5.5/6.0/7.0/CS

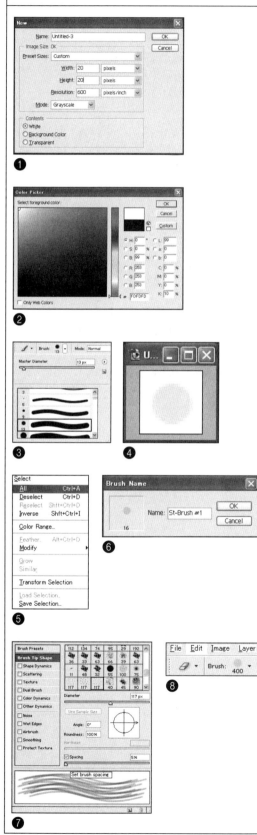

1. Start your graphics software and select File → New... to create a new image.

2. Set the resolution of your new image to 600 dpi, set the mode to grayscale, and set the width and height to around 20 pixels (see fig. ❶).

3. Select the Brush Tool from the Tool Palette. Click on the color swatch in the Tool Palette, set the C, M, and Y values to 0, set the K value only to 10, and create a new color (see fig. ❷).

*In version 5.0/5.5, set the C, M, and Y values to 0, and the K value only to 1 to create a new color.

4. Select the Brush from the Tool Options Bar. Next, select a brush between 8 and 15 pixels (see fig. ❸).

*In version 5.0/5.5, select Window → from the Brushes again.

5. Select the Brush Tool from the Tool Palette, and paint a single dot in your new image (see fig. ❹).

6. Choose Select → All to select the entire image (see fig. ❺).

7. Select Edit → Define Brush..., give your brush a name, and save it (see fig. ❻).

*In version CS, select Edit → Define Brush Preset, save the brush you have created.

*In version 5.0/5.5, select Window → Brushes again, choose Define... from the menu at the right, and save the brush you have created.

8. Open Window → Brushes, and select the brush you saved. Then select Brush Tip Shape in the menu in the upper left, and set the spacing to between 1 and 10%. The larger the spacing percentage, the wider an area the brush you are making will be able to etch (see fig. ❼).

*In version 6.0, select the Eraser Tool from the Tool Palette, and click on the brush you saved with it still selected in the Tool Options bar, and set the spacing between 1 and 10%.

*In version 5.0/5.5, select Window → Brush Options, and set the spacing between 1 and 10%.

9. Bring up the brush you made by selecting the Eraser Tool from the Tool Palette, setting the Mode to Brush, and clicking on the Brushes pull-down menu in the Tool Options bar. The brush you saved is all the way at the bottom. Select it and use it to etch a tone (see fig. ❽).

*In version 5.0/5.5, select the Eraser Tool from the Tool Palette, select the brush you saved from the Brushes Palette and then use it to etch a tone.

For Photoshop Elements 1.0/2.0

1. Start your graphics software and select File → New... to create a new image.

2. Set the resolution of your new image to 600 dpi, set the mode to grayscale, and set the width and height to around 20 pixels (see fig. ❶).

3. Select the Brush Tool from the Tool Palette. Click on the color swatch in the Tool Palette, set each RGB value to 236, and create a new color (see fig. ❷).

4. Select the Brush from the Tool Options Bar. Next, select a brush between 8 and 15 pixels (see fig. ❸).

5. Paint a single dot in your new image (see fig. ❹).

6. Choose Select → All to select the entire image (see fig. ❺).

7. Select Edit → Define Brush..., give your brush a name, and save it (see fig. ❻).

8. Bring up the brush you made by selecting the Eraser Tool from the Tool Palette, click on the eraser icon in the Tool Options bar. The brush you saved is all the way at the bottom. Select it and use it to etch a tone (see fig. ❼).

*Select the Brush Tool from the Tool Palette, and then select More Options... at the far right end of the Tool Options bar. A new window will open; by setting the Spacing in that window to approximately 1 to 10%, you will be able to etch smoothly (see fig. ❽).

For Jasc Paint Shop Pro 7.0/8.0

1. Start your graphics software and select File → New... to create a new image.

2. Set the resolution of your new image to 600 dpi, set the mode to grayscale (8 bit), and set the width and height to around 20 pixels (see fig. ❶).

3. To select a color open the Materials palette and choose a color from the Colors tab that has R, G, and B values of 236 (see fig. ❷).

4. Select the Paint Brush from the Tool Palette. In the Tool Options bar, select Normal for Mode, a round shape, 10 to 15% Size, 90% Hardness, and 100% Opacity (see fig. ❸).

5. Paint a single dot in your new image.

6. Choose Selections → Select All to select the entire image (see fig. ❹).

7. In the Paint Brush Tool Options bar, select Custom from the Pen Mark menu (see fig. ❺).

8. Click Create and call up your brush (see fig. ❻).

9. Next, click on Edit, and set the Step value between 1 and 10% (see fig. ❼).

10. Finally, hit OK to save your brush.

11. In the Paint Brush Tool Options bar, select Custom from the Pen Mark menu, choose your brush from the display and use it to etch a tone (see fig. ❽).

12. To express smooth etching, always set the Paint Brush's Opacity to between 50 and 80% on the Tool Options bar.

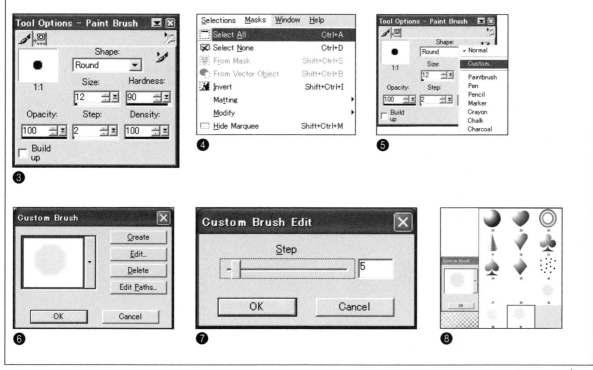

Bokashi kezuri ["Blur Etching"]

Use a large airbrush to give three-dimensionality to a smooth, dark eye, and then add highlights using bokashi kezuri. Use the airbrush to create fuzzed highlights. While the airbrush tends to be the most basic and commonly used digital tool, its overuse could cause your artwork to look overly simplistic and redundant. Use it strategically.

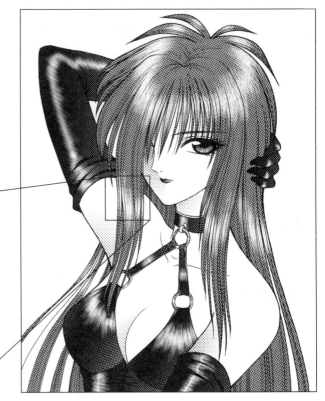

Fuzzed highlights become areas of luster. The brighter the fuzzed highlight, the stronger the light source seems. If an article of clothing's fabric is smooth, such as rubber, vinyl, or leather, then fuzzed highlights become an effective technique.

Bokashi kezuri Used According to the Material Portrayed

Streetlight

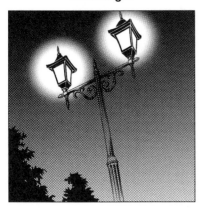

Aluminum Plate

Shine on a Hemispheric Cabochon [Gem Cut with No Facets] Cut Stone or Pearl

This technique is superb for portraying glossy light or sheen. Also give consideration to the gradation interval you apply to create diffuse streetlights or smooth metallic surfaces, etc.

How to Etch with Gradations
For Photoshop4.0/5.0/5.5/6.0/7.0/CS

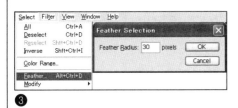

①

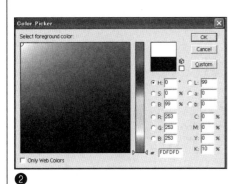

②

③

④

1. Start your graphics software and select File → New... to create a new image.

2. Set the resolution of your new image to 600 dpi, set the mode to grayscale, and set the width and height to around 400 pixels (see fig. ①).

3. Select the Pencil Tool from the Tool Palette. Click on the color swatch in the Tool Palette, set the C, M, and Y values to 0, set the K value only to 10, and create a new color for the dot (see fig. ②).

*In version 5.0/5.5, set the C, M, and Y values to 0, and the K value only to 1 to create a new color.

4. Select the Brush from the Tool Options Bar. Next, select a brush 300 pixels and draw a large dot in your new image.

5. Select the Magic Wand from the Tool Palette and click on the dot you drew to select the entire thing. Next, Choose Select → Feather, set it to 30 pixels, and apply a gradation to your dot (see fig. ③).

6. Fill in the dot with the Paint Bucket Tool from the Tool Palette (see fig. ④).

7. Choose Select → All to select the entire image.

8. Select Edit → Define Brush..., give your brush a name, and save it (see fig. ⑤).

*In version 5.0/5.5, select Window → Brushes again, choose Define... from the menu at the right, and save the brush you have created.

9. Bring up the brush you made by selecting the Eraser Tool from the Tool Palette, click on the eraser icon in the Tool Options bar. The brush you saved is all the way at the bottom. Select it and use it to etch a tone (see fig. ⑥).

*In version 5.0/5.5, select the Eraser Tool from the Tool Palette,

⑤

⑥

For Photoshop Elements 1.0/2.0

1. Start your graphics software and select File → New... to create a new image.

2. Set the resolution of your new image to 600 dpi, set the mode to grayscale, and set the width and height to around 400 pixels (see fig. ❶).

3. Select the Pencil Tool from the Tool Palette. Click on the color swatch in the Tool Palette, set the R, G, and B values to 236, and create a new color for the dot (see fig. ❷).

4. Select the Brush from the Tool Options Bar. Next, select a brush 300 pixels and draw a large dot in your new image. Fill in the dot with the Paint Bucket Tool from the Tool Palette (see fig. ❸).

5. Select the Magic Wand from the Tool Palette and click on the dot you drew to select the entire thing.

6. Next, Choose Select → Feather, set it to 30 pixels, and apply a gradation to your dot (see fig. ❹).

7. Choose Select → All to select the entire image (see fig. ❺).

8. Select Edit → Define Brush..., give your brush a name, and save it (see fig. ❻).

9. Bring up the brush you made by selecting the Eraser Tool from the Tool Palette, click on the eraser icon in the Tool Options bar. The brush you saved is all the way at the bottom. Select it and use it to etch a tone (see fig. ❼).

*Select the Brush Tool from the Tool Palette, and then select More Options... at the far right end of the Tool Options bar. A new window will open; by setting the Spacing in that window to approximately 1 to 10%, you will be able to etch smoothly (see fig. ❽).

For Jasc Paint Shop Pro 7.0/8.0

1. Start your graphics software and select File → New... to create a new image.

2. Set the resolution of your new image to 600 dpi, set the mode to grayscale (8 bit), and set the width and height to around 250 pixels (see fig. ❶).

3. Select the Pencil Tool from the Tool Palette. To select a color open the Materials palette and choose a color from the Colors tab that has R, G, and B values of 236 (see fig. ❷).

4. Select the Paint Brush from the Tool Palette. In the Tool Options bar, select Normal for Mode, a round shape, and 50% Hardness (see fig. ❸).

*Your dot should be no larger than 230 pixels in either dimension.

5. Paint a large single dot in your new image.

6. Choose Selections → Select All to select the entire image (see fig. ❹).

7. In the Paint Brush Tool Options bar, select Custom from the Pen Mark menu (see fig. ❺).

8. Click Create and call up your brush (see fig. ❻).

9. Next, click on Edit, and set the Step value between 1 and 10% (see fig. ❼).

10. Finally, hit OK to save your brush.

11. In the Paint Brush Tool Options bar, select Custom from the Pen Mark menu, choose your brush from the display and use it to etch a tone (see fig. ❽).

12. To express smooth etching, always set the Paint Brush's Opacity to between 50 and 80% on the Tool Options bar.

Brush Etching

This method of etching involves creating an effect that appears as if countless, fine bristles of an actual paintbrush were used to create the highlights. Use a tool you have made or found yourself to produce the effect of numerous bristles scratching across the tone at once. To prevent the finish touch from appearing flat and uninteresting, be sure to use an abundance of fine strokes and to give flow to the etching.

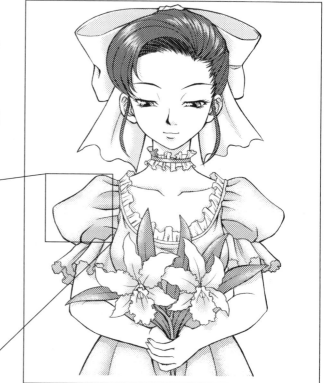

The brush etching technique is extremely effective for rendering hair, producing a look highly reminiscent of the flow of real hair. With respect to materials with a sheen, this technique is also particularly well suited toward depicting natural leather.

Brush Etching Used According to the Material Portrayed

Marsh or Other Watery Surface

Heels

Leather Coat

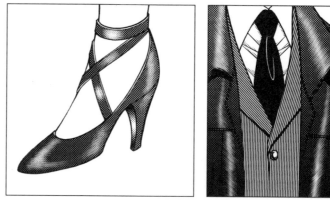

When etching a watery surface or a fabric, imagine the direction the light shines on the surface, and follow that as a guideline when etching. When etching leather products such as women's high-heeled shoes or a coat, have the etches flow on a diagonal from the center of the target area.

How to Etch with a Brush
For Photoshop4.0/5.0/6.0/7.0/CS

1. Start your graphics software and select File → New... to create a new image.

2. Set the resolution of your new image to 600 dpi, set the mode to grayscale, and set the width and height to around 120 pixels (see fig. **1**).

3. Select the Pencil Tool from the Tool Palette, and draw 10 to 15 dots in your new image (see fig. **2**).

*The size of each dot should be about 8 to 10 pixels. You can modify this setting in the Window → Brushes tab.

4. Click on the color swatch in the Tool Palette, set the C, M, and Y values to 0, set the K value only to 10, and create a new color for the dot (see fig. **3**).

*In version 5.0/5.5, set the C, M, and Y values to 0, and the K value only to 1 to create a new color.

5. Fill in the dot with the Paint Bucket Tool from the Tool Palette (see fig. **4**).

6. Open Window → Brushes, select Brush Tip Shape from the menu in the upper left, and set the spacing to between 1 and 10% (see fig. **5**).

*In version 6.0, select the Eraser Tool from the Tool Palette, and click on the brush you saved with it still selected in the Tool Options bar, and set the spacing between 1 and 10%.

*In version 5.0/5.5, select Window → Brush Options, and set the spacing between 1 and 10%.

7. Choose Select → All to select the entire image (see fig. **6**).

8. Select Edit → Define Brush..., give your brush a name, and save it (see fig. **7**).

9. Bring up the brush you made by selecting the Eraser Tool from the Tool Palette, click on the eraser icon in the Tool Options bar. The brush you saved is all the way at the bottom. Select it and use it to etch a tone (see fig. **8**).

*In version 5.0/5.5, select the Eraser Tool from the Tool Palette, select the brush you saved from the Brushes Palette and then use it to etch a tone.

For Photoshop Elements 1.0/2.0

1. Start your graphics software and select File → New... to create a new image.

2. Set the resolution of your new image to 600 dpi, set the mode to grayscale, and set the width and height to around 120 pixels (see fig. ❶).

3. Select the Pencil Tool from the Tool Palette, and draw 10 to 15 dots in your new image (see fig. ❷).

*The size of each dot should be about 8 to 10 pixels.

4. Click on the color swatch in the Tool Palette, set each RGB value to 236, and create a new color (see fig. ❸).

5. Fill in the dot with the Paint Bucket Tool from the Tool Palette (see fig. ❹).

6. Choose Select → All to select the entire image (see fig. ❺).

7. Select Edit → Define Brush..., give your brush a name, and save it (see fig. ❻).

8. Bring up the brush you made by selecting the Eraser Tool from the Tool Palette, click on the eraser icon in the Tool Options bar. The brush you saved is all the way at the bottom. Select it and use it to etch a tone (see fig. ❼).

*Select the Brush Tool from the Tool Palette, and then select More Options... at the far right end of the Tool Options bar. A new window will open; by setting the Spacing in that window to approximately 1 to 10%, you will be able to etch smoothly (see fig. ❽).

For Jasc Paint Shop Pro 7.0/8.0

1. Start your graphics software and select File → New... to create a new image.

2. Set the resolution of your new image to 600 dpi, set the mode to grayscale (8 bit), and set the width and height to around 120 pixels (see fig. ❶).

3. To select a color open the Materials palette and choose a color from the Colors tab that has R, G, and B values of 236 (see fig. ❷).

4. Select the Paint Brush from the Tool Palette. In the Tool Options bar select Pen for Mode (see fig. ❸).

*Your dot should be about 8 to 10 pixels in size.

5. Draw 10 to 15 dots in your new image (see fig. ❹).

6. Choose Selections → Select All to select the entire image (see fig. ❺).

7. In the Paint Brush Tool Options bar, select Custom from the Pen Mark menu (see fig. ❻).

8. Click Create and call up your brush (see fig. ❼).

9. Next, click on Edit, and set the Step value between 1 and 10% (see fig. ❽).

10. Finally, hit OK to save your brush.

11. In the Paint Brush Tool Options bar, select Custom from the Pen Mark menu, choose your brush from the display and use it to etch a tone (see fig. ❾).

12. To express smooth etching, set the Paint Brush's Opacity to between 50 and 80% on the Tool Options bar.

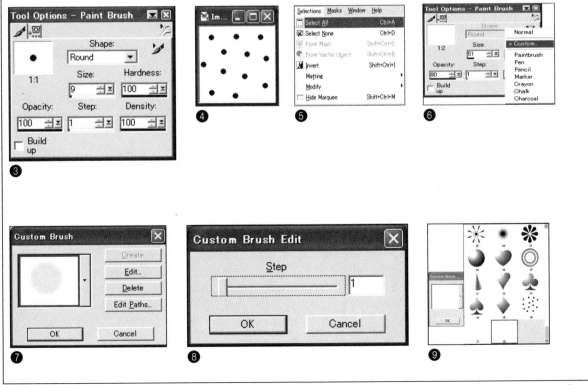

Graphic Software Glossary of Terms

While each of the Computones-compatible graphics software packages (Photoshop, Photoshop Elements, and Jasc Paint Shop Pro) differs slightly in their operation, the terminology they use is almost the same. Here, we will explain some specialized vocabulary that, along with the terms used for creating brushes, will be sufficient for your purposes. Get a good grasp on their meaning, and you will be making your own original brushes.

Size

This is where you specify if you will create a small brush or something a little bigger. However, creating large brushes from the beginning is not suited for etching purposes. So, it would be a good idea to make a smaller brush, and increase the size setting upward little by little as you go.

Hardness

Use this setting to adjust how hard or soft your brush marks appear. Hard settings make edges (and rounded corners) appear smooth and clear. Soft settings make the edges appear proportionally blurrier.

Spacing and Step

These indicate how closely brush marks in a stroke are bunched together. Narrowing the distance between brush marks makes them flow together, while widening it makes each brush mark appear as an independent dot. Normally, you will use your brushes on a narrow setting.

Roundness

This setting determines the roundness of each brush mark. The higher you set it, the more your brush strokes will appear as edgeless round dots.

Opacity

Use this setting to determine the level of opacity for a color you specify in the Color Picker before you paint. The higher this value is set the more opaque the color will become. Lower values make it more transparent. Normally you will use this at a low setting; the more you use it on your fills and tones the more they will start to disappear.

Density

This setting determines the level of color density in your brush marks. Higher values make the color more like a fill, while lower values show gaps in your brush marks.

Supplement: Pen Pressure

Pen Pressure is one feature found in most graphic software packages or with pen tablets, and for the most part is something you can only use with a tablet.

By using Pen Pressure, you can make very slight adjustments in the amount of ink that comes out of your Brush (or the amount you erase with the Eraser Tool) by varying the pressure you apply on your tablet. Interested users should look further into their graphic software and tablet settings for more information.

Chapter 3
Human Figure

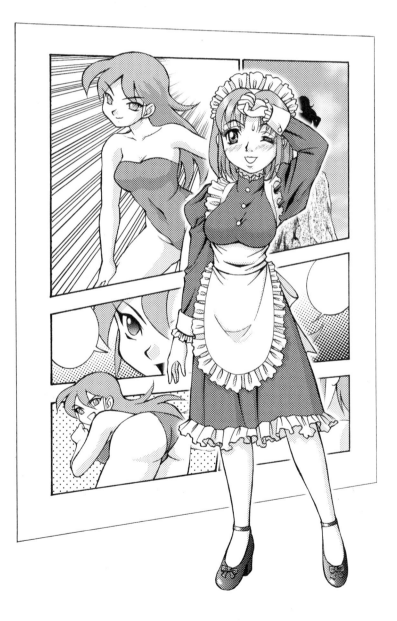

Using Digital Tone to Render Shadows on the Human Form

Being Familiar with Facial Shadows

There are many hills and valleys on the face: the eyes, the nose, the chin, etc. While there is no reason to represent each and every one faithfully, using shadows allows you to emphasize the silhouette or to make the face appear more solid. It is perfectly acceptable for you to render your shadows in sharply cut shapes. Or, you could make them more realistic by using some of the techniques we discuss in the preceding chapter and modulate the darkness of shadows, using gradation from light areas to shadow according to the apparent intensity of light.

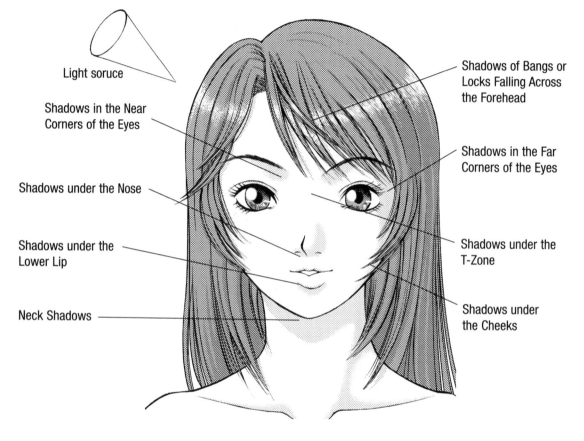

Light soruce

Shadows in the Near Corners of the Eyes

Shadows under the Nose

Shadows under the Lower Lip

Neck Shadows

Shadows of Bangs or Locks Falling Across the Forehead

Shadows in the Far Corners of the Eyes

Shadows under the T-Zone

Shadows under the Cheeks

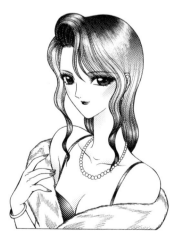

Using Digital Tone to Suggest Cosmetics

When creating a female character wearing makeup, artists may use dot tone or gradation tone on her eyes and mouth to suggest eye shadow and lipstick. Digital tones selected usually tend to be dot tones between a 30% and 50% density or a gradation tone.

Use Digital Tone Shadows According to the Character's Age

Where you would add tone or how you would etch it varies according to whether a character is male or female, and again according to age. The trick is to use rounded shapes for small children and increase the sharpness and angularity as the character's age increases.

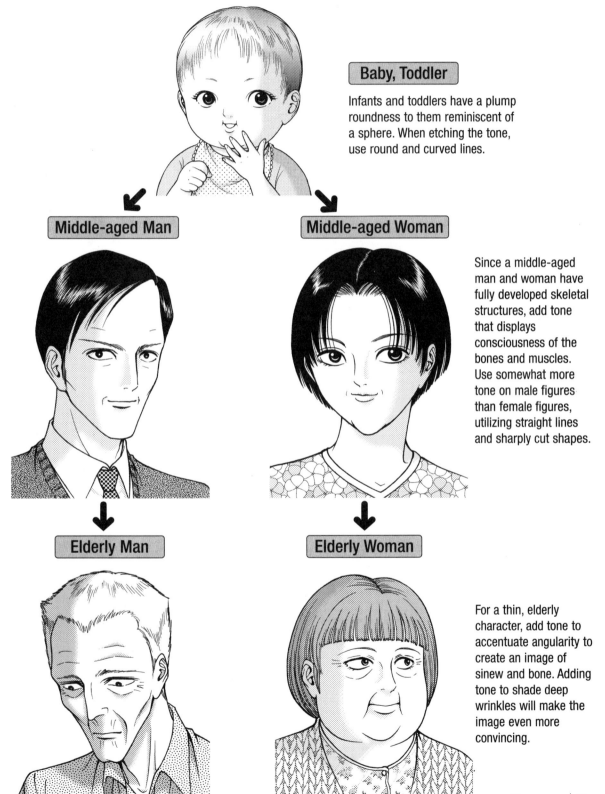

Baby, Toddler

Infants and toddlers have a plump roundness to them reminiscent of a sphere. When etching the tone, use round and curved lines.

Middle-aged Man

Middle-aged Woman

Since a middle-aged man and woman have fully developed skeletal structures, add tone that displays consciousness of the bones and muscles. Use somewhat more tone on male figures than female figures, utilizing straight lines and sharply cut shapes.

Elderly Man

Elderly Woman

For a thin, elderly character, add tone to accentuate angularity to create an image of sinew and bone. Adding tone to shade deep wrinkles will make the image even more convincing.

Using Digital Tone on the Various Facial Features

Eyes

Usually the eyes are rendered using a dark tone for the pupil and a lighter tone for the iris. Using black fill for the pupil suggests a strong-willed character. In contrast, using a light tone for the pupil suggests a synthetic eye or a character lacking his or her own will (e.g. the character has been brain-washed, etc.).

Pupil Rendered in Black Fill and Iris in Gradation Tone

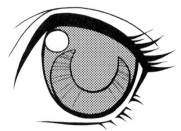

Pupil and Iris Rendered in Dot Tone

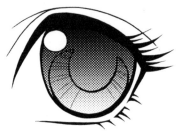

Pupil and Iris Rendered in Gradation Tone

Pupil Rendered in Layered Dot Tone

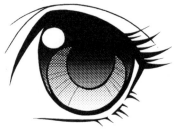

Pupil Rendered in Layered Gradation Tone

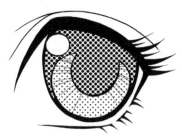

Pupil and Iris Rendered in Large Dots

Ears

How detailed you have drawn in pen the ears, nose, mouth, and other features will affect how the tone will be distributed. If the auricle has been rendered in intricate detail, then layer the tone used for the ear canal to make it darker. Black fill will enhance the sense of realness only in those cases where the ear has been drawn in exceedingly meticulous detail.

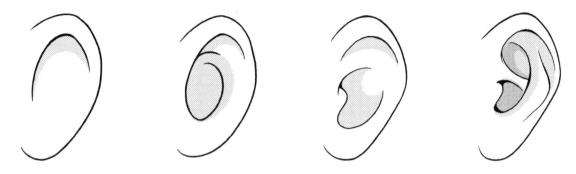

Nose

Tone is rarely used on the nose itself. Customarily, tone use is reserved for the shadows underneath the nose. However, you could be adventurous and leave out the bridge of the nose, instead using digital tone shadows to suggest the nose's shape (c.f. second figure on the left).

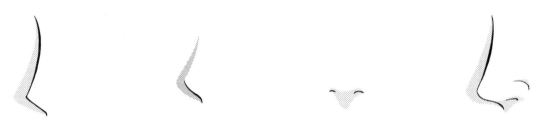

Mouth

Shadow underneath the lower lip enhances the sense of three-dimensionality. The inside of the mouth tends to be darker than the face, so artists frequently use digital tone. Layered tone or gradation tone is used when we can see all the way to the back of the throat. Laying tone over the lips and then etching the center evokes the sense of lustrous lips. Using darker tone on the lips suggests the presence of lipstick.

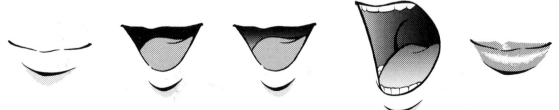

Rendering Hair Using Digital Tone

Keep in mind the flow of the hair and the facial expression when etching.

Etching highlights into hair rendered with digital tone gives the hair more dynamism as well as three-dimensionality. The more luster given to the hair, the lighter the hair's color and weight will seem.

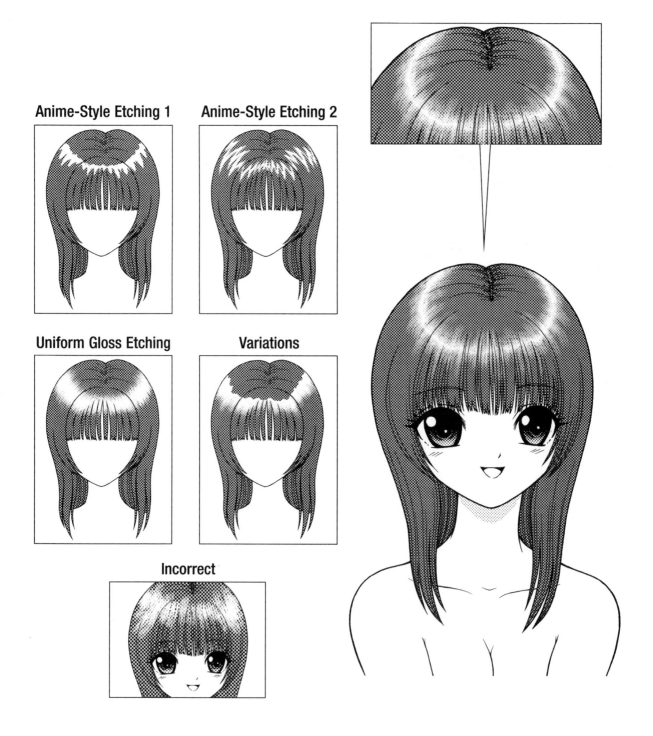

Anime-Style Etching 1

Anime-Style Etching 2

Uniform Gloss Etching

Variations

Incorrect

Hairstyles and Digital Tone Types Vary

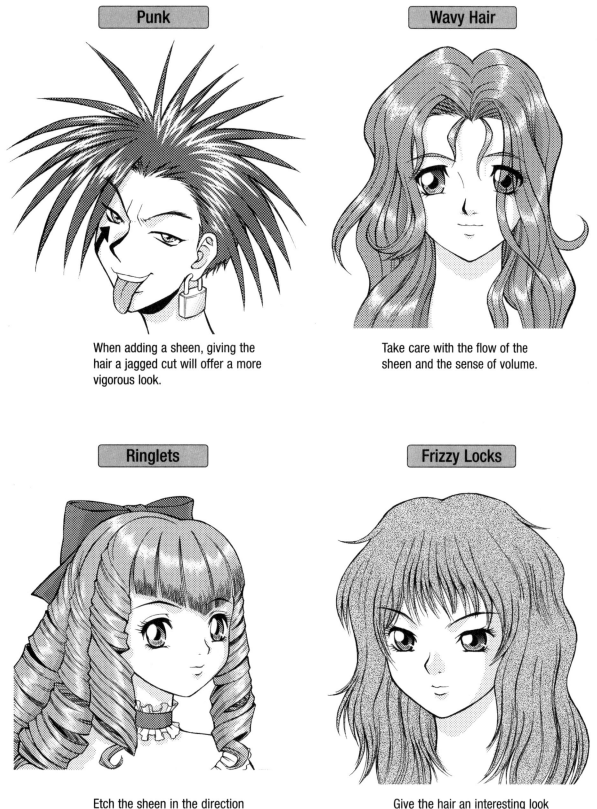

Punk

When adding a sheen, giving the hair a jagged cut will offer a more vigorous look.

Wavy Hair

Take care with the flow of the sheen and the sense of volume.

Ringlets

Etch the sheen in the direction the hair curls.

Frizzy Locks

Give the hair an interesting look by adding sand tone to produce a matte-like finish

Using Tones to Express Emotion

The mood the face projects varies according to digital tone usage.

When you intend to show a range of emotions, not only rendering the face in penned lines, but also adding tone to certain areas allows you to make the target facial expression extra convincing. Dot tones between 10% and 30% density are the most commonly used for facial expressions.

Happy/Joyful

To suggest flushed cheeks when depicting a happy mood, add tone to the cheeks and then use bokashi kezuri [blur etching] to finish. Another interesting touch would be to add a shine to the top of the cheeks. Use the same means for depicting joyful or fun.

Bashful/Embarrassed

This is similar to when depicting a "happy" mood; however, no shine is added to the cheeks. Instead, they just redden. You may also add red to the tip of the nose, but note that red on the nostrils will cause the look of embarrassment to disappear.

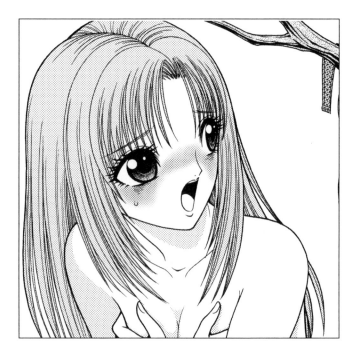

Sad/Forlorn

Adding tone to the upper half of the face, such as around the eyes, etc., underscores the sense of sadness. Laying down the tone without etching it or attaching dark tone evokes a dejected mood. Add bokashi kezuri in an unaffected, natural way or apply light tone, and the mood shifts from sad to lonely.

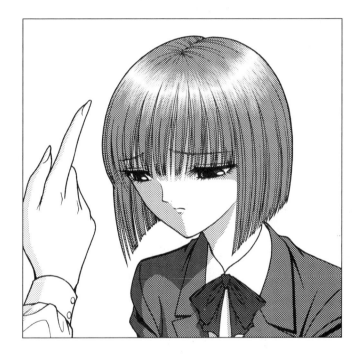

Angry/Patient

As with a sad expression, this involves adding tone to the face to create shadows as well as around the eyes. However, penning in furrows at the brow and then adding dot tone to generate shadows allows you to create an even sterner expression. Furthermore, covering the face in digital tone and then etching the outline allows you to produce an absolutely furious expression.

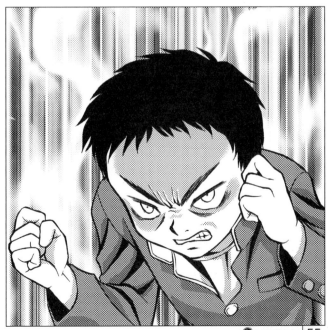

School Uniforms

Using Tone with Clothing

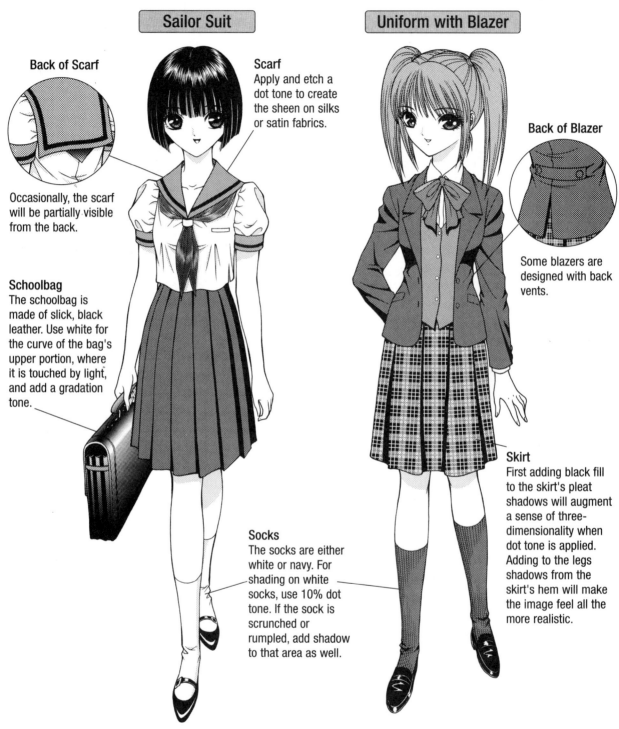

Sailor Suit

Back of Scarf

Occasionally, the scarf will be partially visible from the back.

Scarf
Apply and etch a dot tone to create the sheen on silks or satin fabrics.

Schoolbag
The schoolbag is made of slick, black leather. Use white for the curve of the bag's upper portion, where it is touched by light, and add a gradation tone.

Socks
The socks are either white or navy. For shading on white socks, use 10% dot tone. If the sock is scrunched or rumpled, add shadow to that area as well.

Uniform with Blazer

Back of Blazer

Some blazers are designed with back vents.

Skirt
First adding black fill to the skirt's pleat shadows will augment a sense of three-dimensionality when dot tone is applied. Adding to the legs shadows from the skirt's hem will make the image feel all the more realistic.

Winter sailor suits feature tops and skirts of the same color, while on a summer sailor suit, either only the collar is the same color as the skirt, or the collar is of a lighter color. The skirt should be navy blue, so aim for tone of approximately 30% density.

For uniforms with blazers, either both the jacket and skirt are the same color, or the skirt has a plaid print. Use a plaid tone pattern for the plaid skirt.

Uniform with Stand-up Collar

Collar

The collar is fastened with a hook. Class and school lapel pins adorn both sides.

School Lapel Button

The button is brass and decorated with the school emblem. Because the button is so detailed, dot tone should be used only in close-ups, with the tone etched to suggest the design in relief.

Sports Bag

Because this is made of vinyl or other such material with a sheen, bring out a sense of three-dimensionality by strategically etching with bokashi kezuri to create highlights.

The color scheme is black or, albeit rarely, navy. Using only black fill will cause the composition to feel heavy. Instead, attach 50% dot tone or gradation tone to make the image more convincing.

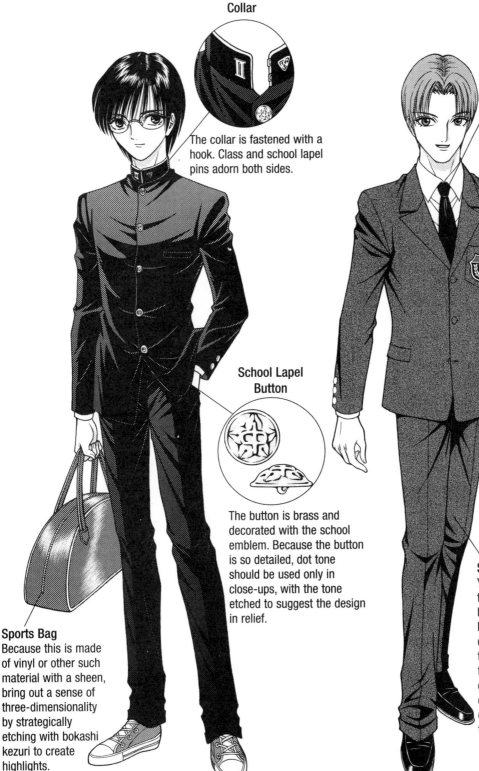

Uniform with Blazer

Necktie

The student necktie is plain. Occasionally a school tiepin is also worn.

Emblem

The emblem is embroidered, making it raised, so in close-ups dot tone should be used with the gold regions of the emblem etched.

Slacks

You may either keep the same tones for both the top and bottom, or use a different tone density than that used for the top. When adding a dark dot tone, first lay down black fill to enhance the sense of three-dimensionality.

These come in a wide variety of colors, from camel to black. A fine, uniform sand tone or herringbone tone is occasionally used to represent wool fabrics.

Casual and Formal Wear

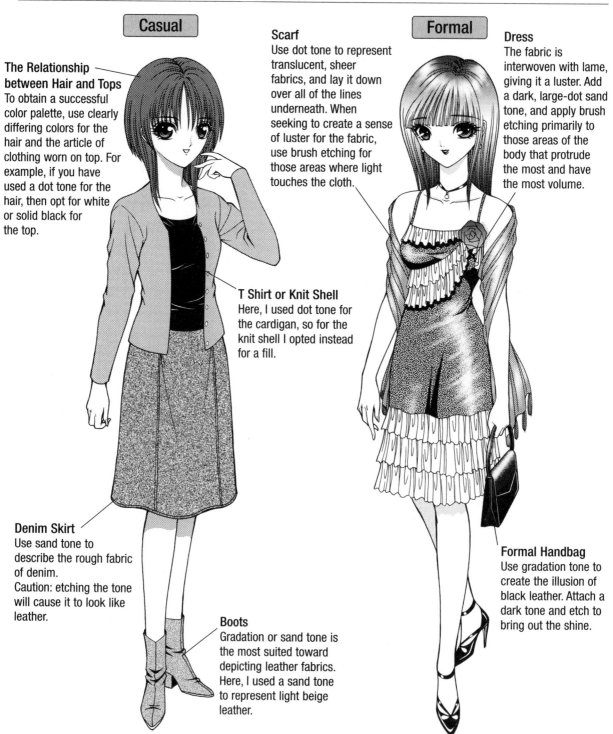

Casual

The Relationship between Hair and Tops
To obtain a successful color palette, use clearly differing colors for the hair and the article of clothing worn on top. For example, if you have used a dot tone for the hair, then opt for white or solid black for the top.

Scarf
Use dot tone to represent translucent, sheer fabrics, and lay it down over all of the lines underneath. When seeking to create a sense of luster for the fabric, use brush etching for those areas where light touches the cloth.

Formal

Dress
The fabric is interwoven with lame, giving it a luster. Add a dark, large-dot sand tone, and apply brush etching primarily to those areas of the body that protrude the most and have the most volume.

T Shirt or Knit Shell
Here, I used dot tone for the cardigan, so for the knit shell I opted instead for a fill.

Denim Skirt
Use sand tone to describe the rough fabric of denim.
Caution: etching the tone will cause it to look like leather.

Boots
Gradation or sand tone is the most suited toward depicting leather fabrics. Here, I used a sand tone to represent light beige leather.

Formal Handbag
Use gradation tone to create the illusion of black leather. Attach a dark tone and etch to bring out the shine.

Cotton tends to be the preferred fabric for street clothes, with dot tone being the digital tone of choice. Note that overuse of light dot tone will cause the overall image to lose its distinctness.

Adding a sheen or luster to a dress imparts it with a more formal appearance. Be sure to add black fill underneath areas of shadow in order to get the most effective use of highlights.

Casual

Denim Jacket and Jeans
Use a dark, low line count dot tone to represent dark blue denim. To give the fabrics a lighter feel, sand tone may be used instead.

Sneakers
Use dot tone for logos and other prints as well as for colored lines.

Formal

Collar
In the case of formalwear, occasionally only the collar is silk. To suggest a silk collar, lay down gradation tone and etch the center using the brush etching technique.

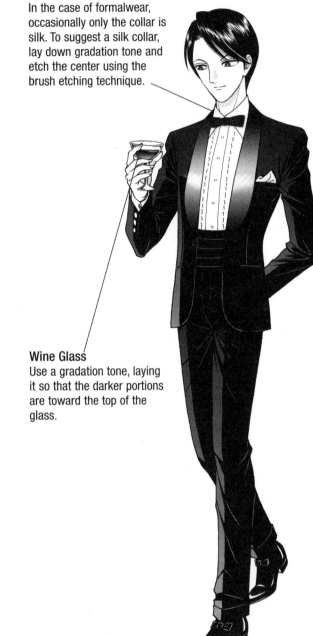

Wine Glass
Use a gradation tone, laying it so that the darker portions are toward the top of the glass.

Coordinating white with light tone produces an overall pastel look, suggesting a gentle character. Applying black fill or dark tone allows you to evoke a more active, energetic mood.

Use black as the base color and tweak it a little to give it a luster. Create lots of highlights, add gradation tone, and link them together using black fill.

Sports

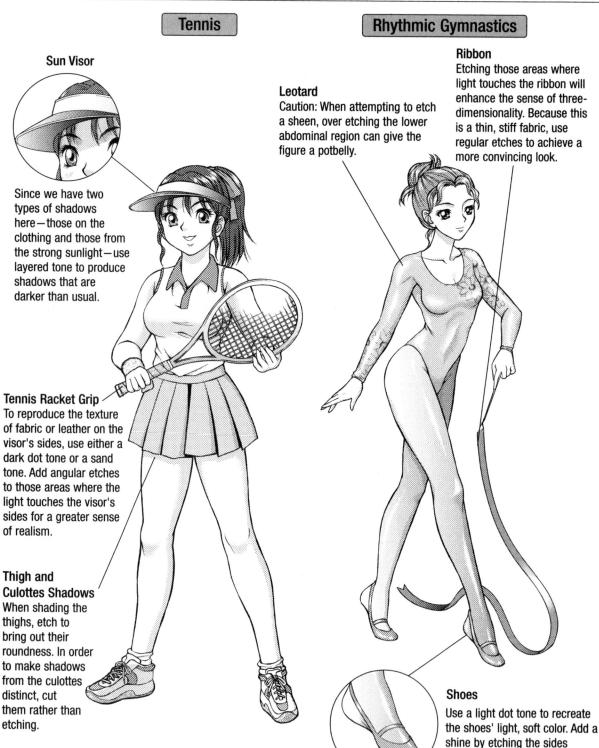

Sun Visor

Since we have two types of shadows here—those on the clothing and those from the strong sunlight—use layered tone to produce shadows that are darker than usual.

Leotard
Caution: When attempting to etch a sheen, over etching the lower abdominal region can give the figure a potbelly.

Ribbon
Etching those areas where light touches the ribbon will enhance the sense of three-dimensionality. Because this is a thin, stiff fabric, use regular etches to achieve a more convincing look.

Tennis Racket Grip
To reproduce the texture of fabric or leather on the visor's sides, use either a dark dot tone or a sand tone. Add angular etches to those areas where the light touches the visor's sides for a greater sense of realism.

Thigh and Culottes Shadows
When shading the thighs, etch to bring out their roundness. In order to make shadows from the culottes distinct, cut them rather than etching.

Shoes
Use a light dot tone to recreate the shoes' light, soft color. Add a shine by etching the sides touched by light or etching the center at a diagonal.

To stress the whiteness of clothing, use a light dot tone, adding it to areas of creases, etc. If the scene takes place in a sunny setting, select a 20% density tone.

Leotards are made of highly lustrous fabrics, so opt for 10% to 20% density dot tone. Etch any projecting areas on the body—especially the chest and shoulders.

Judo

Dogi
Judo gear is made of heavy, white cotton. Before laying down dot tone over areas of shadow, using a pen, draw in lines at the shadows' centers to suggest soiling. This will evoke the proper atmosphere. In the case of blue judo gear, select a dot tone of approximately 30% density, and use layered tone for shading.

Kendo

Dogi
The dogi contains plastic, which wraps around the abdominal region. Use bokashi kezuri to produce a luster. For a dulled shine to suggest extensive use, minimize the degree of bokashi kezuri, and randomly add fine strokes.

Mask Back

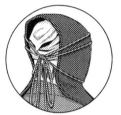

Tying the mask in the back fastens it to the head. Use a light dot tone of no more than 20%.

Mask Front
The front of the mask features an iron grille. Apply a dot tone or a light gradation tone, etching primarily those areas where the light touches the grille.

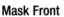

Rear of Dogi

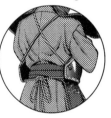

The dogi has ties to fasten.

Obi [Belt]
Beginners wear green belts (dot tone of approximately 30%), while advanced students wear brown belts (dot tone of approximately 40% to 50%). The highest levels wear black belts.

Hakama [Men's Kilt]
The hakama is either black or navy. Consequently, shadows of black fill should be used at the hem and then a dark dot tone added.

As with judo, kendo gear is made of heavyweight cotton that is typically navy in color. To suggest navy blue, opt for a dark 40% to 50% density dot tone. Add highlights to the protective gear covering the abdomen to generate a more realistic look.

Specialty Dress

Ceramic

To create the ceramic, gradation tone was used over white ground to create shadows, and then blurred to suggest a smooth, glossy finish.

Mandarin Dress

Hair Ornament
This ornament was crafted from a lustrous fabric. Use the brush etching technique to create fine strokes for highlights.

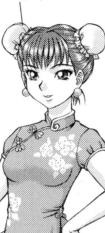

Dress
When using both patterned tone and dot tone for shadows to create a kimono or a mandarin dress, be sure to etch only the dot tone and not the patterned tone, which constitutes the base for your dress. Add highlights to the waist, the abdomen, and the chest to evoke a sense of volume.

High Heels

When pairing an outfit with high heels, select the digital tone according to the darkness and shape of the clothing.

Use a patterned tone as the base and then add dot tone for the shadows. The dress is made of satin, so it has a lustrous sheen. Go ahead and lay down a wide swath of light, 10% to 20% density dot tone, and then add lots of bokashi kezuri to enhance the sense of gloss.

Miko

Hair Tie
The hair is loosely bound in back. Since the hair tie is white, use a light dot tone when shading.

Tabi
Almost all tabi (socks) for women are white. Use a light, 10% dot tone for shading.

The miko's garment, which symbolizes the sacredness of her role, is white with a red hakama worn underneath. To achieve the desired impression of the dull texture of cotton, do not etch to add a sheen of any sort. Apply an approximately 30% dot tone for the red hakama worn underneath, and overlap using a light 10% to 20% density dot tone to shade.

Head Guard
The head guard is made of steel. Use a dark gradation tone and add fine etches to mimic the look of metal fitting and produce a metallic finish.

Ninja Kunai (Short Sword)
Lay down gradation tone to evoke a sense of solidness. Since you want to create the look of a white shine, apply tone and use the brush etching technique to bring out the bright areas.

Kyahan [Gaiters]
Kyahan are made of a stiff fabric. Consequently, a light sand tone should be used to suggest the cotton's course texture.

Tabi and Waraji [Straw Sandals]
Tabi worn by ninja are black, like the rest of their garments. Waraji are sandals made of straw. Use a light sand tone in a close-up.

Sword
The ronin has two swords tucked into his obi. He wears a long sword on the outside, and a short sword on the inside. Draw the sword's blade facing upward. When adding the hilt, lay sand or dot tone over the entire figure and etch along the pattern primarily to create a luster for those areas touched by light.

People tend to picture ninja as dressed entirely in black. However, in fact, ninja wear various colors, depending on their role. For this figure, picture the ninja dressed in khaki and add a dark sand tone. To reproduce the matte-like finish of ninja garb, use black fill for shading, avoiding etching for luster.

A Ronin is a masterless samurai. Draw dramatic ripples and creases on the clothing, opting for a masculine, unpretentious and austere look. Sand tone would also work well toward the desired effect.

Machines and Synthetic Objects

Adding gloss to suggest a synthetic look.

The greater the amount of white surface, the lighter [from a weight perspective] the object seems. Conversely, the darker the object is, the heavier it appears. To give an object a weighty feel, first apply black fill as primer to areas of shadow. Next, layer tones to expand dark areas on the object's surface. Use the brush etching technique to create a metallic glare or bokashi kezuri to suggest soft reflections.

How highlights are etched on a sphere affects the sense of weight projected.

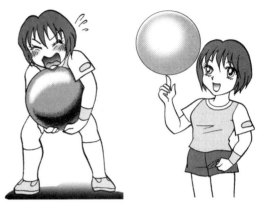

Heavy sphere　　　　　Light sphere

Assorted Modes of Depicting Metallic Finishes

Apply gradation tone and etch highlights around the object's silhouette. Use plenty of highlights to create a metallic feel.

Apply gradation tone and use the brush etching technique to etch the brightest areas.

While visualizing round light reflections, create fine etches using the brush etching or bokashi kezuri technique.

For objects with centrally positioned reflections, use gradation tone to darken the centers.

After applying a dark dot tone, add highlights at regular intervals using straight lines.

Apply speed line digital tones so that the lines run parallel to the object's outline. This is a simple but effective technique.

Creating a Metallic Finish

Depicting Glistening Reflections

Apply the light portion of a gradation tone from the blade's hilt to its point. Add fine etches to the center areas using the brush etching technique.

Trumpet

Suggesting a Metallic Gloss on a Cylindrical Form

Horns are a compilation of metallic, cylindrical shapes. Consequently, I recommend applying black fill to areas of reflection and then surround with speed lines.

Cell Phone

Suggesting Shine on a Rounded, Enameled Surface

Use soft forms for shine appearing on corners or the round casing. Add dot tone of 20% to 30% density and apply fine etches for glossy areas.

Using Digital Tone to Suggest Soil on Synthetic Objects

Making a Car Look Old

It is important for an artist to soil mechanical and synthetic objects in a convincing way to make them appear more authentic. In the case of a car, apply tone to painted surfaces and add dirt or scratches to give the car a weathered look. The trick is to add minor etching to sand [random dot] tone. Furthermore, rather than making rounded highlights, apply a brush that you have made yourself randomly to the pen tablet to create a haphazardly etched look intentionally, thus producing a rough, sharp shine.

Mud

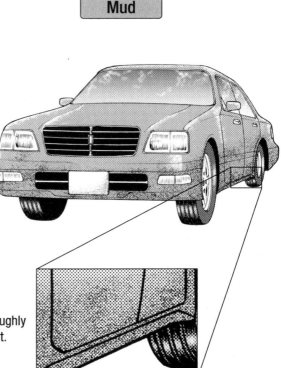

Use sand [random dot] tone to suggest mud. Apply the tone underneath the car and etch roughly to suggest mud splashing about.

Scratches

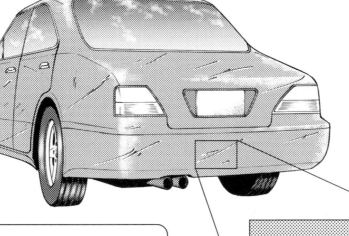

To begin, pen in lines for the scratch marks. Next, apply tone and then add stroke etching over that.

Tip!

It is difficult to create a soiled look using solely etching. Therefore, pen in lines to represent scratches or dirt before adding tone to augment the look.

Other Modes for Portraying Dirt and Scratches

Scuffs and Abrasions

Randomly add fine stroke etches to tone applied to the car's body.

Bullet Marks

Add black fill for shadows forming in the dent, apply tone over the black fill, and then etch the dent's outline.

Dents

Apply rounded segments of sand [random dot] tone to "indented" areas. Add fine etches to the center using the brush etching technique. Finally, lay on top tone to suggest the car's painted finish. This should result in a "dented" look.

Broken Rearview Mirror

Apply dot tone of 20% to 30% density or gradation tone and etch highlights along the "crack."

COLUMN

Making a Car Look Brand Spanking New

Balance is critical when depicting a new car. Adding gradation tone to the car's various parts, retaining some of the car's silhouette, and adding crisp, clear highlights will evoke a sense of volume.

Using Special Effects Tone to Enhance the Sense of Realism

Using Line Tone and Speed Line Tone to Project a Sense of Speed

Digital tone is indispensable to imparting movement on a mechanical or synthetic object, and speed lines are the most commonly used for creating a sense of speed. In addition, successful use of digital tone also allows you to "explain" what is happening in a given scene.

Radiating Lines 02

Radiating Lines 03

Parallel Rays

Use Burst Effect Tone to Generate a Sense Of Speed

You may use this in scenes where a car is accelerating and moving toward the picture plane. Place burst effect tone so as to make the car appear to be emerging from the burst's center.
*If the car is not aligned with the burst's center, then it will not appear to be moving.

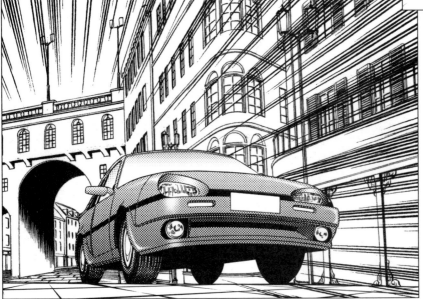

Using Speed Lines to Give a Car in Horizontal Motion a Sense of Speed

A sense of speed is not achieved merely by showing a car in profile. Consequently, applying tone with parallel, horizontal lines or special effects tone allows you to evoke a sense of speed. Please note, however, that adding such tone to a car facing diagonally will make the car appear to be skidding sideways, so use caution.

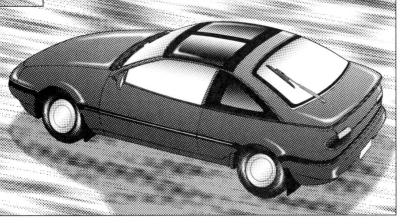

Using Burst Effect Tone to Impart a Forward Moving Car with a Sense of Dynamism

Add burst effect tone as a backdrop in scenes where a car is heading directly toward the viewer. To maximize the effectiveness, select a tone where the vanishing point is located in the center and then align the car with the center.

COLUMN

Make the car's shadow move too!

In addition to applying tone to the car's body or special effects tone, adding tone for the car's shadow to make it appear to be moving will enhance the scene's authenticity. I recommend either using the brush etching technique to etch in the direction that the car is supposed to be moving, or if the car is supposed to be still, then either not etching the shadows or using the brush etching technique to blur contour lines.

Basic Techniques in Applying Digital Tone to Cars

Key Points in a Car's Paint Finish

Digital tones using on a car may be roughly divided into two categories: body paint, and car parts and accessories. Dot and gradation tones are most commonly used for body paint. Add layered tone to the sides and shadows to evoke a sense of volume. If etching, use bokashi kezuri to create a soft gloss to broad surfaces.

Forward Facing Car

Side Shadows
Evoke a sense of volume using layered tone.

Wheels
To generate a metallic look, apply gradation tone to the lower half and then etch using the brush etching technique.

Front Windshield
Apply gradation tone to reproduce the texture of glass. When needed, etch using the bokashi kezuri technique.

Body Paint
Apply dot or gradation tone. If the car is white, use dot or gradation tone and then etch using bokashi kezuri.

You could omit drawing the character(s) inside the car and instead use digital tone to render the character(s) in silhouette form. If the character lacks a sense of presence, you might draw the viewer's attention toward the car.

Rearward Facing Car

Turn signal
This area is orange, yellow, or colorless. Use 10% to 30% dot tone.

Rearview mirror
Apply gradation tone without alternation.

Tires
First, use black fill for the shadows and then add a dark dot or gradation tone on top of that. Adding highlights using the brush etching technique in the direction the wheel is turning will enhance the sense of the car moving.

Shadow
Apply dark gradation tone to subdue the shadows, thus drawing out the car's sense of volume.

Use Digital Tone to Distinguish Car Type

Cars that appear in manga bear a relationship with the characters that use them. You will need to distinguish between various car types according to the storyline. Adjust the image projected by the paintjob and your tone work according to the car type to indicate these differences.

Classic Cars

Combining colors projecting a non-glossy look and drawing out a shine will create the appearance of a classic car. Use 30% density dot tone as your foundation, applying a light dot tone as needed according to the design. Blur highlights to give them a smooth, soft appearance.

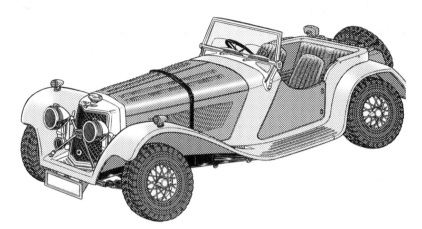

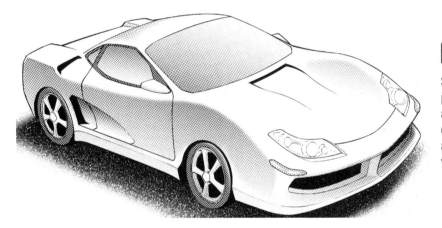

Sports Cars

Select a light gradation tone to use primarily with shadows and create a clean, slick feel. If the car has color [i.e. not black or white], then apply layered tone to those areas with color.

Luxury Sedans (Rolls Royce and the Like)

Imagine a polished black finish like that found on a black-lacquered piano. Lay down black fill for the shadows. Next, add gradation tone touching the black fill. Clearly delineate the outline, and fuzz one side to achieve the look of a highly glossy finish.

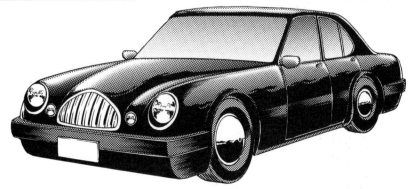

Basic Techniques in Applying Digital Tone to Motorcycles

Key Points in a Motorcycle's Paint Finish

Motorcycles tend not to have color. However, the paintjob does play a primary role in the image. Visualize what color and what type of body paint your motorcycle has when creating its finish. The tires are another prominent feature, so apply black fill for the shadows and next lay down a dark sand [random dot] tone on top to finish.

Windshield
Apply a light gradation tone to the windshield keeping the windshield's center light. In the case of tinted glass, make both sides of the glass dark. In the case of light [clear] glass, apply tone only to those sides not reflecting light.

Body Paint
If the motorcycle has color [i.e. not black or white], use layered tone for the shaded areas. Use the bokashi kezuri technique along the curved contours of the fairing to create highlights.

Tires
First apply either black fill or a dark sand [random dot] tone to areas of shade on the tire. Next, overlap with a dark sand tone.

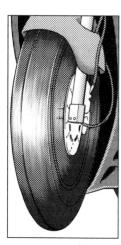

If the wheel is supposed to be turning, add circular highlights and shadows to the tire in the direction that it is turning.

Basic Techniques in Applying Digital Tone to Bicycles

Key Points in a Bicycle's Paint Finish

The bicycle comprises an assembled metal frame. To suggest shadow, apply gradation tone to narrow areas to evoke a sense of volume. Layering gradation tone with dot tone is another option; however, I recommend avoiding this technique as it tends to result in moire.

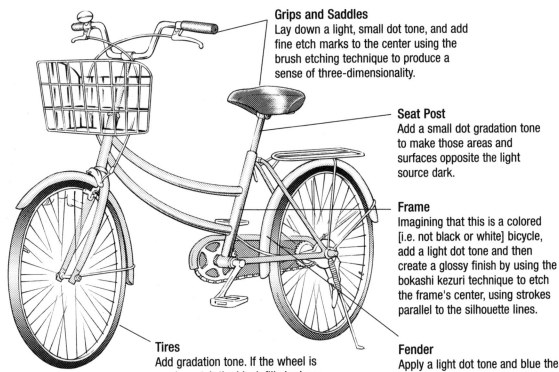

Grips and Saddles
Lay down a light, small dot tone, and add fine etch marks to the center using the brush etching technique to produce a sense of three-dimensionality.

Seat Post
Add a small dot gradation tone to make those areas and surfaces opposite the light source dark.

Frame
Imagining that this is a colored [i.e. not black or white] bicycle, add a light dot tone and then create a glossy finish by using the bokashi kezuri technique to etch the frame's center, using strokes parallel to the silhouette lines.

Tires
Add gradation tone. If the wheel is moving, etch the black fill shadows using an actual brush or the like on the pen tablet to create a shine.

Fender
Apply a light dot tone and blue the center following the curved contour.

Racing Bike

Garish, bright patterns or designs often appear on bicycle frames, so use a patterned tone that appeals to you. To achieve a sense of volume, use a dark palette for the shadows on the lower portions of the frame and overlap with a gradation tone cut into narrow pieces.

Basic Techniques in Applying Digital Tone to Airplanes

Use the Digital Tone's Degree of Light/Dark Indicate the Strength of the Light Source

Airplanes tend to have white fuselages. Accordingly, I opt for an approximately 20% dot tone for the shadows. Using a smooth bokashi kezuri to soften edges should create a satisfactorily convincing look. For bright reflections, 30% to 50% density tones work well.

Nose
In order to duplicate light reflecting on the pointed nose of the airplane, fuzz and soften edges using the bokashi kezuri technique.

Colored Areas on the Side of the Fuselage
Apply a 30% to 50% density dot tone, and use a darker tone in order to distinguish the colored areas from shadows appearing on the fuselage.

Shadows
In a compositional diagram drawn from a low angle, the area in shadow increases. Apply 10% to 20% dot tone to the airplane, extending over outlines somewhat, and etch to blur the lines between airplane and shadow.

Tires
Apply a dark gradation tone to achieve a look close to a black fill.

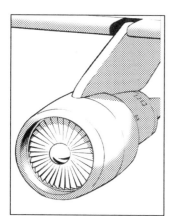

Enlarged view of the engine
The engine should appear to have a non-glossy silver finish. In order to evoke a sense of three-dimensionality, use bokashi kezuri along the engine's curved contours. Note that not etching shadows on a turbine engine will result in a more convincing image.

Basic Techniques in Applying Digital Tone to Boats and Waves

Cruiser

Use overall a 10% dot tone for the shadows and etch along the boat's outlines at the water's surface, producing highlights by creating fine etches on a pen tablet with a brush or similar object you have made. Layer dark 30% to 50% density dot tones for those areas with color and for the hull's underside. Apply a gradation tone for the water's surface, and scatter fine, white, etched strokes for water spray from the waves.

Etching Waves

Use primarily gradation tone for the waves. Press a brush or the like on a pen tablet at the center of the waves' crests to create fine highlights.

Sailboat

The key point in applying digital tone to sails is that one side is always in shadow. If the sail is white, opt for a light 10% to 20% dot tone. If the sail has a design on it, then overlap the light dot tone with a darker dot tone. For the boat itself, apply a dot tone to one side to create shadows. To suggest light reflecting off the water, use a brush or similar object on a pen tablet to create fine highlights.

Gallery of Tones Depicting Mechanical and Synthetic Textures

Helicopter

Fuselage23 Dots 60.0 Line(s) 30%
Light Areas on the Fuselage.....22 Dots 60.0 Line(s) 20%
Window81 Dots Gradation 60.0 Line(s) 100-0% 33.0cm
 80 Dots Gradation 60.0 Line(s) 100-0% 22.0cm
Mountain35 Sand 40.0 Line(s) 10% 24x33cm
 38 Sand 40.0 Line(s) 40% 24x33cm
Sky...................................22 Dots 60.0 Line(s) 20%

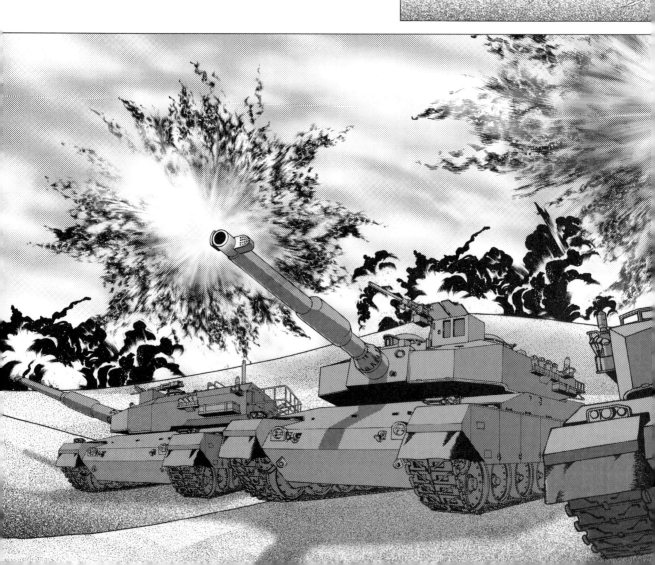

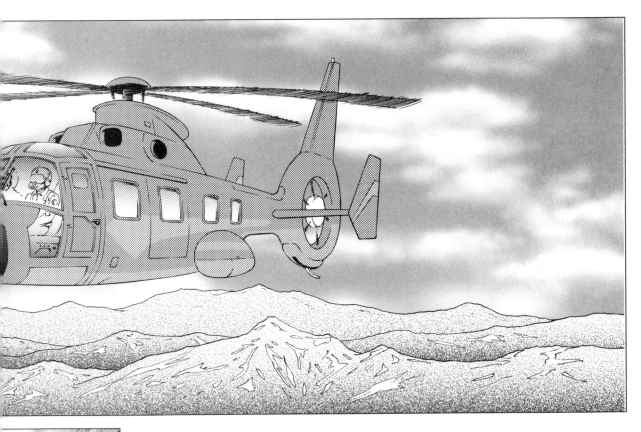

Tank

Tank	23 Dots 60.0 Line(s) 30%
	24 Dots 60.0 Line(s) 40%
	25 Dots 60.0 Line(s) 50%
Desert	35 Sand 40.0 Line(s) 10% 24x33cm
	37 Sand 40.0 Line(s) 30% 24x33cm
Waves	84 Dither Gradation 100-0-100% 33x17cm
Sky	22 Dots 60.0 Line(s) 20%
Smoke	64 Rendering Lines 05 (24x17cm)
Burst Effect	27 Dots 60.0 Line(s) 70%

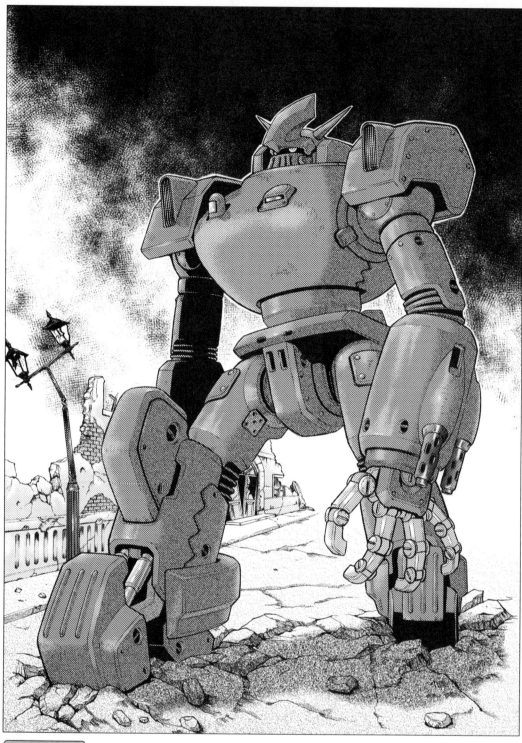

Robot

Shadow	42 Sand 75.0 Line(s) 20% 24x33cm
Main Unit	22 Dots 60.0 Line(s) 20%
Machine Gun Sensor	72 Dots Gradation 60.0 Line(s) 100-0-100% 1.0cm
Suspension	67 Speed Line(s) 03 (24x17cm)
Ground Shadow	39 Sand 40.0 Line(s) 50% 24x33cm
Bricks	41 Sand 75.0 Line(s) 10% 24x33cm
Street Lights	25 Dots 60.0 Line(s) 50%
Ground	85 Dither Gradation 100-0-100% 33x33cm
Background	45 Sand 75.0 Line(s) 50% 24x33cm

Chapter 4

Manual

Chapter 1: Preliminaries

System Requirements
• Have installed at least one of the following:
 Adobe Photoshop 5.0/5.5/6.0/7.0/CS or Adobe Photoshop LE 5.0; Adobe Photoshop Elements 1.0/2.0; Jasc Paint Shop Pro 7.0/8.0.

• Use one of the following operating systems:
 Microsoft Windows 98 SE, Windows ME, Windows 2000, or Windows XP.

• Meet or exceed the following hardware specifications:
 Intel Pentium or 100% compatible CPU (Pentium 3 800 MHz or higher recommended)
 CD-ROM drive
 128MB RAM or more (256MB or more recommended)
 250MB or more of free local disk space (950MB or more recommended)

 Adobe Photoshop Elements and Jasc Paint Shop Pro limit certain operations, and Computones' Autolayer functionality will not work with them. However, it is possible to manually create a new layer and lay it atop an image. For more details, consult the Software Functions Table on the next page. Further, there is no guarantee that this software will function perfectly with other Photoshop plug-in-compatible software packages that are not listed above.

1-2 Computones-Compatible Image File Formats
The image file formats Computones will and will not support are listed below.

Supported:
Grayscale
Duotone
RGB Color
CMYK Color
Lab Color

Not Supported:
Bitmap
Indexed Color
Multichannel
All 16 Bits/Channel modes

Chapter 2: Photoshop 5.0/5.5/6.0/7.0/CS

This chapter is for readers using Photoshop 5.0/5.5/6.0/7.0/CS.

Before You Install
These installation notes are for all supported operating systems (Microsoft Windows 98 SE, Windows Me, Windows 2000, or Windows XP).

- Make certain you have Photoshop 5.0, 5.5, 6.0, 7.0, or CS (hereafter "Photoshop") installed.

- Shut down any antivirus software or any other background applications, and adjust your operating system so that your machine does not go into sleep mode during installation.

- Having multiple graphics software packages installed on the same machine can interfere with the normal use of this software.

Installing Computones
"Computones" is made up of a tone plug-in and a Computones-specific data set made up of tones. Follow the installation steps below in order to use them.

Step 1
Insert the Computones CD-ROM into a CD-ROM drive.

Step 2
Double-click on the My Computer icon on the Windows desktop (Windows XP users should click on the Start Menu and then click on My Computer), and double-click on the Computones CD-ROM icon. The Computones Installer.exe (or simply "Computones Installer") icon will appear. Double-click on it to start the installation.

Step 3
You will be asked to which folder or directory you want to install Computones. Select "Install in the Photoshop Plug-Ins folder." The installer will then automatically search for the plug-ins folder and install Computones.

Step 4
Next, install the Computones-specific tone data set.

If "Also copy tone files" is checked, then the plug-in, tone data, and tone sets on the CD-ROM will be selected and written to the local disk.

If "Also copy tone files" is not checked, then Tone and other utility programs will be installed, but every time you use the plug-in, the tone data and sets on the CD-ROM will need to be read from it.

If "Browse for tone file install location" is checked together with "Also copy tone files," then you can choose to which folder you will install the tone files.

Step 5
When you click on the Install button, you will be prompted to confirm the install folder. If everything is OK, then click on the Yes button and the installation will begin. If there is a problem with the selected folder, then click on the No button. You will then have to check "Browse for tone file install location" and manually specify the install folder. When you have done so, click on the OK button.

- In the following cases, Computones will not be able to automatically search for an install folder, and so you must check "Browse for tone file install location" and then manually specify the install folder. This will also be necessary if the error message shown here should appear at any other point.

1) The Photoshop Plug-Ins folder has somehow been changed.
 The installer will only search for the Plug-Ins folder inside the Photoshop install folder. In any other case, manually specify the install location.

2) There is more than one graphics software package installation.
 The installer will automatically search for the Photoshop install folder. If the folder it finds is not what you normally use, then manually specify the install folder for you do normally use for Photoshop.

3) The automatic search may fail for reasons not covered by the above. In such cases, manually specify the Photoshop folder.

Step 6

When you have confirmed the install folder and hit the OK button, if you have checked "Also copy tone files," then a dialog box titled, "Select installation files" will appear. This box will not appear if you have not checked this option, and you may proceed to Step 8. The list on the left side of the window will show the tone file groups present on the CD-ROM, while the list on the right shows the tone file groups to be installed. If there is some tone file group in the list on the right that you will not be using, select it from the list and hit the Remove button. When all the file groups you want have been added, click on the OK button.

Step 7

If you have checked "Browse for tone file install location" and begun the installation, then you can choose where you wish to create the folder that will hold all the tone files. A dialog box will appear asking you about this; at that point, specify the folder as you wish. If you have not checked "Browse for tone file install location," then a tone file install folder will automatically be created within the plug-in install folder, and no dialog box will appear.

Step 8

Once the installation begins, a progress bar will be displayed. The installation may take some time, so if you are using a computer with a battery, please make sure you are also using an AC adapter when you install Computones. Hitting the Cancel button will stop the installation, and tone files in mid-installation will automatically be deleted. Once the installation is complete, a window will appear indicating so. Click on the OK button.

Step 9
After the installation is complete, launch Photoshop. If you select File → New... and create a new file, "Computones" will be displayed in the Filter menu. From there you can start using tones.

```
Installation complete                                    [X]

 (i)    Installation complete. Click the OK button to finish the installation.

                        [        OK        ]
```

*If "Computones" is not displayed in the Filter menu, then it is possible that the folder in which the Plug-Ins reside and the plug-in install folder are different. You can check the location of the Plug-Ins folder at Edit → Preferences in Photoshop 6.0/7.0/CS (File → Preferences in Photoshop 5.0/5.5) under "Plug-Ins and Scratch Disks..."

Step 10
Once you have launched Photoshop, open the "Companion.psd" file located in the Sample folder on the Computones CD-ROM. Open the Filter menu and start up Computones. Immediately after startup, you will be asked just once for a serial number. Enter the serial number at the first of this book and click on OK.

Step 11
Installation is now complete.

Try Using Some Tones
Let's get started right away!

Step 1
Start Photoshop, access Edit → Preferences in Photoshop 6.0/7.0 (Files → Preferences in Photoshop 5.0/5.5), and select "General..." A new window will open, and in that window is an Interpolation pull down menu. Select "Nearest Neighbor (fastest)" in that menu and click on OK.

Step 2
Select File → Open...and an Open window will appear so you can select a file to read in. Open the Companion.psd file in the Sample folder on the Computones CD-ROM.

Step 3

Adjust the resolution of the sample image you opened in Step 2. Adjust it to match the resolution of the printer you are using such that one is an integral multiple of the other. For example, if you are using a printer capable of printing 720 dpi images, set your image resolution to be 360 or 720 dpi. If the horizontal and vertical printer resolutions are different (for example, 1440 x 720 dpi), then your image resolution should be a multiple of one or the other. In theory, a 1440 dpi resolution would be usable, but from a quality perspective it is too high. A lower setting is better.

To change the image resolution in Photoshop, click on Image → Image Size... A window will pop up; input a new value where the "600" is displayed in the Resolution field. Keep in mind the units are in pixels/inch.

- If you don't know the output capabilities of your printer, it does not matter if you leave the setting (600 dpi) as is, but printed copies of your image may look blurry as a result.

Step 4

Use Photoshop's Magic Wand Tool to select the collar area of the clothing on the figure in your sample image. We will call this selected portion the "Tone Draw Area." Now set the Magic Wand Tool's Tolerance value to 1, and uncheck Anti-aliased.

- Please consult your Photoshop manual for more on the Magic Wand and its option bar. Using tones without specifying a Tone Draw Area will automatically make the entire image the effective Tone Draw Area.

Step 5

Select Filter → Computones → Tone...

- If "Computones" does not appear in the Filter menu, please go back to the "Installing Computones" section and review the installation process.

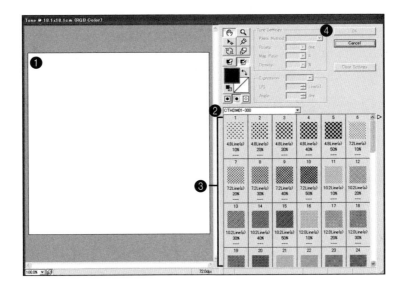

Step 6

In the middle of your screen, a Computones window will appear. At the left side of that window, there is a "Preview Display," and in it part of the image will be displayed at a 100% display ratio.❶

Step 7

Click on the Tone Set Selection pull-down menu and select the "CTHDM01-600" tone set. The contents of the tone set are displayed at the bottom right in the Tone Set Area.❷

- If you did not check the "Also copy tone files" box at installation, then every time you use tones they will be read directly from the Computones CD-ROM. Therefore, when you are using Computones you must make sure the CD-ROM is in the CD-ROM drive at all times.

Step 8

Try clicking on a tone you like from the Tone Set Area. We recommend you try out the "50.0 Line(s) 10%" dot tone. (If you don't see an exact match, choose a tone with similar values.)❸

Step 9

Click on a tone, and it will cover the Tone Draw Area you specified in Step 4. If you would like to change tones, just click on another tone in the Tone Set Area.

- If you'd like to specify a different Tone Draw Area, then you have to go back to Photoshop first, and execute this process from Step 4 again.

Step 10

If you would like to apply the effects you have created to the sample image, then hit the OK button. After the tone you have selected has been applied, you will go back to Photoshop. If you print out your work, you can see the real results in more minute detail.

If you would rather not apply the effects you have created to the sample image, then click on the Cancel button. The sample image will be unchanged, and you will return to Photoshop.❹

Chapter 3: Photoshop Elements 1.0/2.0

This chapter is for readers using Photoshop Elements 1.0/2.0.

Before You Install
These installation notes are for all supported operating systems (Microsoft Windows 98 SE, Windows Me, Windows 2000, or Windows XP).

• Make certain you have Photoshop Elements 1.0/2/0 (hereafter "Elements") installed.

• Shut down any antivirus software or any other background applications, and adjust your operating system so that your machine does not go into sleep mode during installation.

• Having multiple graphics software packages installed on the same machine can interfere with the normal use of this software.

Installing Computones
"Computones" is made up of a tone plug-in and a Computones-specific data set made up of tones. Follow the installation steps below in order to use them.

Step 1
Insert the Computones CD-ROM into a CD-ROM drive.

Step 2
Double-click on the My Computer icon on the Windows desktop (Windows XP users should click on the Start Menu and then click on My Computer), and double-click on the Computones CD-ROM icon. The Computones Installer.exe (or simply "Computones Installer") icon will appear. Double-click on it to start the installation.

Step 3
You will be asked to which folder or directory you want to install Computones. Select "Install in the Photoshop Plug-Ins folder." The installer will then automatically search for the Photoshop Elements plug-ins folder and install Computones.

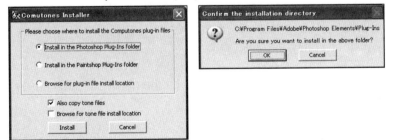

Step 4

Next, install the Computones-specific tone data set.

If "Also copy tone files" is checked, then the plug-in, tone data, and tone sets on the CD-ROM will be selected and written to the local disk.

If "Also copy tone files" is not checked, then Tone and other utility programs will be installed, but every time you use the tone data and sets on the CD-ROM they will need to be read from it.

If "Browse for tone file install location" is checked together with "Also copy tone files," then you can choose to which folder you will install the tone files.

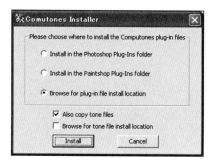

Step 5

When you click on the Install button, you will be prompted to confirm the install folder. If everything is OK, then click on the Yes button and the installation will begin. If there is a problem with the selected folder, then click on the No button. You will have to check "Browse for tone file install location" and then manually specify the install folder. When you have done so, click on the OK button.

- In the following cases, Computones will not be able to automatically search for an install folder, and so you must check "Browse for tone file install location" and then manually specify the install folder. This will also be necessary if any of the error messages shown here should appear at any other point.

1) The Photoshop Elements Plug-Ins folder has somehow been changed.
 The installer will only search for the Plug-Ins folder inside the Photoshop Elements install folder. In any other case, manually specify the install location.

2) There is more than one graphics software package installation.
 The installer will automatically search for the Photoshop Elements install folder. If the folder it finds is not what you normally use, then manually specify the install folder you do normally use for Photoshop Elements.

3) The automatic search may fail for reasons not covered by the above. In such cases, manually specify the Photoshop Elements folder.

Step 6

When you have confirmed the install folder and hit the OK button, if you have checked "Also copy tone files," then a dialog box titled, "Select installation files" will appear. This box will not appear if you have not checked this option, and you may proceed to Step 8. The list on the left side of the window will show the tone file groups present on the CD-ROM, while the list on the right shows the tone file groups to be installed. If there is some tone file group in the list on the right that you will not be using, select it from the list and hit the Remove button. When all the file groups you want have been added, click on the OK button.

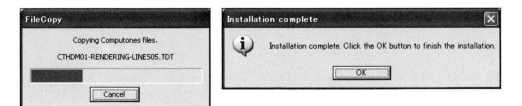

Step 7

Ilf you have checked "Browse for tone file install location" and begun the installation, then you can choose where you wish to create the folder that will hold all the tone files. A dialog box will appear asking you about this; at that point, specify the folder as you wish. If you have not checked "Browse for tone file install location," then a tone file install folder will automatically be created within the plug-in install folder, and no dialog box will appear.

Step 8

Once the installation begins, a progress bar will be displayed. The installation may take some time, so if you are using a computer with a battery, please make sure you are also using an AC adapter when you install Computones. Hitting the Cancel button will stop the installation, and tone files in mid-installation will automatically be deleted. Once the installation is complete, a window will appear indicating so. Click on the OK button.

Step 9

After the installation is complete, launch Photoshop Elements. If you select File →
New... and create a new file, "Computones" will be displayed in the Filter menu. From
there you can start using tones.

If "Computones" is not displayed in the Filter menu, then it is possible that the folder
in which the Plug-Ins reside and the plug-in install folder are different. You can check
the location of the Plug-Ins folder at Edit → Preferences under "Plug-Ins and Scratch
Disks..."

Step 10

Once you have launched Photoshop Elements, open the "Companion.psd" file located
in the Sample folder on the Computones CD-ROM. Open the Filter menu and start up
Computones. Immediately after startup, you will be asked just once for a serial
number. Enter the serial number at the first of this book and click on OK.

Step 11

Installation is now complete.

Try Using Some Tones
Let's get started right away!

Step 1
Start Photoshop Elements, select File → Open... and an Open window will appear so you can select a file to read in. Open the Companion.psd file in the Sample folder on the Computones CD-ROM.

- If you are unsure how to use File → Open..., please consult the Photoshop Elements manual.

Step 2
Adjust the resolution of the sample image you opened in Step 1. Adjust it to match the resolution of the printer you are using such that one is an integral multiple of the other. For example, if you are using a printer capable of printing 720 dpi images, set your image resolution to be 360 or 720 dpi. If the horizontal and vertical printer resolutions are different (for example, 1440 x 720 dpi), then your image resolution should be a multiple of one or the other. In theory, a 1440 dpi resolution would be usable, but from a quality perspective it is too high. A lower setting is better.

To change the image resolution in Photoshop Elements, click on Image → Image Size... A window will pop up; input a new value where the "600" is displayed in the Resolution field. Keep in mind the units are in pixels/inch, and in the lower part of the same window, "Resample Image" is set to "Nearest Neighbor."

- If you don't know the output capabilities of your printer, it does not matter if you leave the setting (600 dpi) as is, but printed copies of your image may look blurry as a result.

Step 3
Use Photoshop Elements' Magic Wand Tool to select the collar area of the clothing on the figure in your sample image. We will call this selected portion the "Tone Draw Area." Now set the Magic Wand Tool's Tolerance value to 1, and uncheck Anti-aliased.

- Please consult your Photoshop Elements manual for more on the Magic Wand and its option bar. Using tones without specifying a Tone Draw Area will automatically make the entire image the effective Tone Draw Area.

Step 4
Select Filter → Computones → Tone...

*If "Computones" does not appear in the Filter menu, please go back to the "Installing Computones" section and review the installation process.

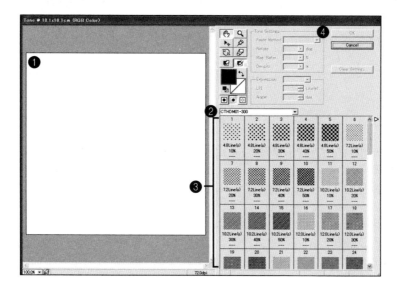

Step 5
In the middle of your screen, a Computones window will appear. At the left side of that window, there is a "Preview Display," and in it part of the image will be displayed at a 100% display ratio.❶

Step 6
Click on the Tone Set Selection pull-down menu and select the "CTHDM01-600" tone set. The contents of the tone set are displayed at the bottom right in the Tone Set Area.❷

*If you did not check the "Also copy tone files" box at installation, then every time you use tones they will be read directly from the Computones CD-ROM. Therefore, when you are using Computones you must make sure the CD-ROM is in the CD-ROM drive at all times.

Step 7
Try clicking on a tone you like from the Tone Set Area. We recommend you try out the "55.0 Line(s) 40%" dot tone. (If you don't see an exact match, choose a tone with similar values.)❸

Step 8

Click on a tone, and it will cover the Tone Draw Area you specified in Step 3. If you would like to change tones, just click on another tone in the Tone Set Area.

• f you'd like to specify a different Tone Draw Area, then you have to go back to Photoshop Elements first, and execute this process from Step 3 again.

Step 9

If you would like to apply the effects you have created to the sample image, then hit the OK button. After the tone you have selected has been applied, you will go back to Photoshop Elements. If you print out your work, you can see the real results in more minute detail.❹

If you would rather not apply the effects you have created to the sample image, then click on the Cancel button. The sample image will be unchanged, and you will return to Photoshop Elements.

1 ————————————	Tone's Code No.
————————————	Tone's Image
20.0 Line(s) ————————	Lines Per Inch (PLI)
10% ————————————	Density
--- ————————————	Size

Chapter 4: Jasc Paint Shop Pro 7.0/8.0

This chapter is for readers using Jasc Paint Shop Pro 7.0/8.0.

Before You Install

These installation notes are for all supported operating systems (Microsoft Windows 98 SE, Windows Me, Windows 2000, or Windows XP).

• Make certain you have Jasc Paint Shop Pro 7.0/8.0 (hereafter "Paint Shop Pro") installed.

• Shut down any antivirus software or any other background applications, and adjust your operating system so that your machine does not go into sleep mode during installation.

• Having multiple graphics software packages installed on the same machine can interfere with the normal use of this software.

Installing Computones

"Computones" is made up of a tone plug-in and a Computones-specific data set made up of tones. Follow the installation steps below in order to use them.

Step 1

Insert the Computones CD-ROM into a CD-ROM drive.

Step 2

Double-click on the My Computer icon on the Windows desktop (Windows XP users should click on the Start Menu and then click on My Computer), and double-click on the Computones CD-ROM icon. The Computones Installer.exe (or simply "Computones Installer") icon will appear. Double-click on it to start the installation.

Step 3

You will be asked to which folder or directory you want to install Computones. Select "Install in the Paint Shop Pro Plug-Ins folder." The installer will then automatically search for the Paint Shop Pro plug-ins folder and install Computones.

Step 4

Next, install the Computones-specific tone data set.

If "Also copy tone files" is checked, then the plug-in, tone data, and tone sets on the CD-ROM will be selected and written to the local disk.

If "Also copy tone files" is not checked, then Tone and other utility programs will be installed, but every time you use the plug-in, the tone data and sets on the CD-ROM will need to be read from it.

If "Browse for tone file install location" is checked together with "Also copy tone files," then you can choose to which folder you will install the tone files.

Step 5

When you click on Install, the installer will ask you to select the folder designated for Paint Shop Pro Plug-Ins if there are multiple folders present. If there is only one folder designated as such, then hit the OK button and the installation will begin. If there is some kind of problem with the install folder, then you will have to hit the No button, check the "Browse for tone file install location" box, and specify the folder manually. When you are done, hit the OK button.

Step 6

When you have confirmed the install folder and hit the OK button, if you have checked "Also copy tone files," then a dialog box titled, "Select installation files" will appear. This box will not appear if you have not checked this option, and you may proceed to Step 8. The list on the left side of the window will show the tone file groups present on the CD-ROM, while the list on the right shows the tone file groups to be installed. If there is some tone file group in the list on the right that you will not be using, select it from the list and hit the Remove button. When all the file groups you want have been added, click on the OK button.

Step 7

IIf you have checked "Browse for tone file install location" and begun the installation, then you can choose where you wish to create the folder that will hold all the tone files. A dialog box will appear asking you about this; at that point, specify the folder as you wish. If you have not checked "Browse for tone file install location," then a tone file install folder will automatically be created within the plug-in install folder, and no dialog box will appear.

Step 8

Once the installation begins, a progress bar will be displayed. The installation may take some time, so if you are using a computer with a battery, please make sure you are also using an AC adapter when you install Computones. Hitting the Cancel button will stop the installation, and tone files in mid-installation will automatically be deleted. Once the installation is complete, a window will appear indicating so. Click on the OK button.

Step 9

After the installation is complete, launch Paint Shop Pro. If you select File → New... and create a new file, "Computones" will be displayed in the Filter menu. From there you can start using tones.

If "Computones" is not displayed in the Filter menu, then it is possible that the folder in which the Plug-Ins reside and the plug-in install folder are different. You can check the location of the Plug-Ins folder at Edit → Preferences under "Plug-Ins and Scratch Disks..."

Step 10

Once you have launched Paint Shop Pro, open the "Companion.psd" file located in the Sample folder on the Computones CD-ROM. Open the Filter menu and start up Computones. Immediately after startup, you will be asked just once for a serial number. Enter the serial number at the first of this book and click on OK.

Let's get started right away!

Step 1

Start Paint Shop Pro, select File → Open... and an Open window will appear so you can select a file to read in. Open the Companion.psd file in the Sample folder on the Computones CD-ROM.

- If you are unsure how to use File → Open..., please consult the Paint Shop Pro manual.

Step 2

Adjust the resolution of the sample image you opened in Step 1. Adjust it to match the resolution of the printer you are using such that one is an integral multiple of the other. For example, if you are using a printer capable of printing 720 dpi images, set your image resolution to be 360 or 720 dpi. If the horizontal and vertical printer resolutions are different (for example, 1440 x 720 dpi), then your image resolution should be a multiple of one or the other. In theory, a 1440 dpi resolution would be usable, but from a quality perspective it is too high. A lower setting is better.

To change the image resolution in Paint Shop Pro, click on Image → Resize... A window will pop up; check "Actual/print size" and input a new value where the "600.000" is displayed in the Resolution field. Keep in mind the units are in pixels/inch, and in the lower part of the same window, "Resize type" is set to "Pixel Resize."

- If you don't know the output capabilities of your printer, it does not matter if you leave the setting (600 dpi) as is, but printed copies of your image may look blurry as a result.

Step 3

After you click on the Magic Wand in the Tool palette, set the options in the Tool Options palette as follows:

1) Set the Match Mode to "RGB Value."
2) Set the Tolerance to 1.
3) Set Feather to 0.

- Please consult your Paint Shop Pro manual for more on the Magic Wand and its Tool Option palette.

Step 4
Use Photoshop Elements' Magic Wand Tool to select the collar area of the clothes on the figure in your sample image. We will call this selected portion the "Tone Draw Area."

*Using tones without specifying a Tone Draw Area will automatically make the entire image the effective Tone Draw Area.

Step 5
Select Effects → Plugin Filter → Computones → Tone...

*If "Computones" does not appear in the Plugin Filter menu, please go back to the "Installing Computones" section and review the installation process.

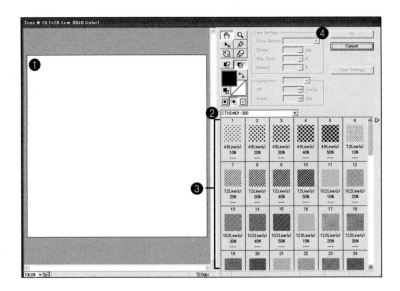

Step 6
In the middle of your screen, a Computones window will appear. At the left side of that window, there is a "Preview Display," and in it part of the image will be displayed at a 100% display ratio. ❶

Step 7
Click on the Tone Set Selection pull-down menu and select the "CTHDM01-600" tone set. The contents of the tone set are displayed at the bottom right in the Tone Set Area. ❷

*If you did not check the "Also copy tone files" box at installation, then every time you use tones they will be read directly from the Computones CD-ROM. Therefore, when you are using Computones you must make sure the CD-ROM is in the CD-ROM drive at all times.

Step 8
Try clicking on a tone you like from the Tone Set Area. We recommend you try out the "55.0 Line(s) 40%" dot tone. ❸

Step 9
Click on a tone, and it will cover the Tone Draw Area you specified in Step 4. If you would like to change tones, just click on another tone in the Tone Set Area.

• If you'd like to specify a different Tone Draw Area, then you have to go back to Paint Shop Pro first, and execute this process from Step 4 again.

Step 10
If you would like to apply the effects you have created to the sample image, then hit the OK button. After the tone you have selected has been applied, you will go back to Paint Shop Pro. If you print out your work, you can see the real results in more minute detail.❹

If you would rather not apply the effects you have created to the sample image, then click on the Cancel button. The sample image will be unchanged, and you will return to Paint Shop Pro.

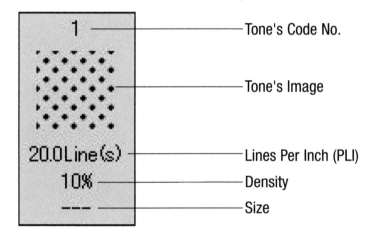

- Tone's Code No.
- Tone's Image
- Lines Per Inch (PLI)
- Density
- Size

Uninstallation

Follow the steps below to uninstall Computones and completely remove it from your local disk.

Step 1

Insert the Computones CD-ROM into a CD-ROM drive.

Step 2

Double-click on the My Computer icon on the Windows desktop (Windows XP users should click on the Start Menu and then click on My Computer), and double-click on the Computones CD-ROM icon. The Computones Uninstaller.exe (or simply "Computones Uninstaller") icon will appear. Double-click on it to start the uninstallation.

Step 3

Next, a dialog box will appear. Choose an uninstallation method and hit the OK button.

"Remove only the plug-in folder"
This option removes the Computones plug-in itself only. The installed tone files stay as they are.

"Remove only the tone folders"
This option completely removes all the installed tone files. The plug-in file will remain, so the Computones plug-in will still be usable.

"Remove both the plug-in and tone folders"
This option completely removes all the installed plug-in and tone files.

Step 4

After starting the uninstaller, all the data covered by the option selected in Step 3 will be removed.

- If you install Computones more than once without uninstalling it, then only the most recently installed plug-in and/or tone files will be removed.

Step 5

If the uninstallation process completes normally, a message indicating so will appear. Hit the OK button.

- If the Computones installer was not used to install Computones, then an error message will appear. The same error will occur if you attempt to remove the tone folder when it does not exist on the local disk. In order to use the uninstaller, the Computones installer must have been used in the first place.

Chapter 5: Computones Functionality Overview

Tone Functions

The area selected via your graphic software determines the area in an image where a tone will be applied. If no such selection is made, then the tone will be applied to the entire image. For normal use, it is recommended that you first use your graphic software to select where in the image the tone is to be applied.

If your screen appears pink, it means that part of your image has been specified as a tone draw area. The actual draw area is the portion not shown in pink, but in white or gray.

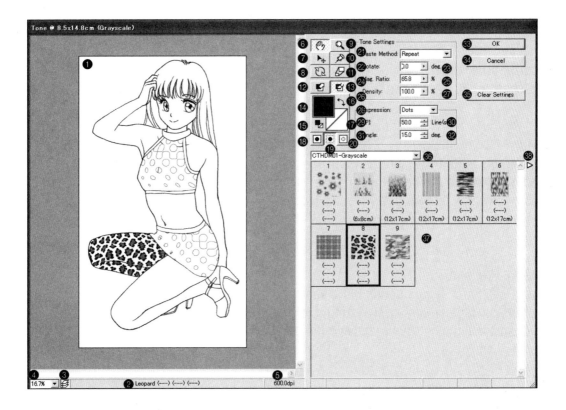

1) Preview Display
You can use this display to see how your image would look with a tone applied. You can use the scroll bars at the right and bottom of the display to scroll through the preview.

2) Selected Tone Info Area
The name, lines per inch (LPI), density, size, and other information on the tone currently applied to the Tone Draw Area are shown here. However, if the tone window is narrow, then all the information might not be displayed. Widening the window will reveal everything.

3) Preview Display Mode button
By turning this button on or off, you can display only the selected area ("Off") or you can display all possible layers, one on top of the other ("On").

• This function is not available in Paint Shop Pro.

4) Preview Display Ratio
Much like the Zoom Tool, clicking on this pull-down menu and then choosing one of the 13 choices inside it changes the display ratio of the image in the preview display. The choices are spread over 13 different steps between 5% and 800%, so you can zoom in or out on your image.

5) Image Resolution
This constant display shows the resolution of your image in dots per inch (DPI).

6) Hand Tool button
Clicking this button will start the Hand Tool, and the cursor will take the shape of a hand. You can use the hand tool to move the image around in the preview display. You can do the same thing with the scroll bars; however, they cannot move pins or applied tones separately.

7) Move Tool button
Hitting this button brings up the Move Tool, and the cursor will change into an arrowhead with four-way arrow. Using it in the preview display allows you to move a pin or an applied tone without moving the image itself.

8) Rotate Tool button
Clicking this button starts the Rotate Tool, and the cursor will change into a curly double arrow. Clicking and dragging on an image with this tool will rotate an applied tone around a pin.

9) Zoom Tool button
Hitting this button brings up the Zoom Tool, and turns your cursor into magnifying glass. You can use this tool to zoom in or out on the preview display over 13 steps, from 5% to 800%. Clicking on the preview display with the Zoom Tool icon as is will zoom in, while holding down the Alt key and clicking on it will zoom out.

10) Pin Tool button

Clicking on this button starts the Pin Tool, turning the cursor into a pin. The Pin Tool "pins" a tone down to a location of your choosing, and then serves as an axis around which you can rotate a tone. You can move the pin by clicking on the preview display; its default location is in the upper right corner of the image.

11) Scale Tool button

Hit this button to bring up the Scale Tool, and the cursor will turn into a double-ended arrow. You can then change the dimensions of an applied tone in all directions (centered on a pin) while maintaining the same image aspect ratio. Also, the magnification factor is indicated in a separate field; you can change this factor by directly entering a different value.

12) Use Host Color button

Hitting this button sets the foreground color to whatever color you are using in Photoshop or another host application, and renders the background transparent. If your Image Mode is set to Render Foreground and Background Colors, then the foreground color is set to transparent, and the background color will be set to whatever color you are using in your host application.

13) Use Custom Color button

If your Image Mode is set to Render Foreground and Background Colors when you press this button, then the foreground color will be rendered in 100% black, and the background color will be set to 100% white. If the Image Mode is set to Render in Foreground Color, then the foreground color will be set to transparent, and the background to 100% white.

14) Foreground Color Selection box

Clicking on this box will start up the Color Picker, and you can use it to change the foreground color. By doing so, you can also change the color of the tone you will be applying. The default foreground color is 100% black. If your Image Mode is set to Render in Foreground Color, the default is set to transparent.

- If you are unfamiliar with the usage of the Color Picker, please refer to your graphic software manual.

15) Restore Default Foreground and Background Colors icon

Clicking this icon sets the foreground color to 100% black and the background color to transparent. If you set the foreground or background colors to anything except 100% black, 100% white, or transparent, this icon will turn into a caution symbol.

16) Swap Foreground and Background Colors icon

Clicking this icon switches the foreground and background colors. You can produce black and white inversion effects this way.

17) Set Background Color box

Clicking on this box will open the Color Picker, and you can use it to change the background color. The default background color is transparent, but if your Image Mode is set to Render Foreground and Background Colors or Render in Background Color, the default is set to 100% white.

- If you are unfamiliar with the usage of the Color Picker, please refer to your graphic software manual.

18) Render Foreground and Background Colors button

Hitting this button will set the Image Mode to "Render Foreground and Background Colors." In Render Foreground and Background Colors mode, it is possible to color both the foreground and background. Each time you start using Tone, the foreground and background color settings will be as you left them the previous time.

19) Render in Background Color button

Hitting this button sets the Image Mode to Render in Background Color. In this mode the background color is set to transparent.

20) Render in Foreground Color button

Hitting this button sets the Image Mode to Render in Foreground Color. In this mode the foreground color appears transparent and is not visible.

21) Paste Method selection

You can choose how you apply a tone by choosing among the selections in this pull-down menu. For dot, line, and sand duotones, you can choose repeat or flip repeat. For radiating line and pattern duotones and grayscales, you can choose flip, flip repeat, don't repeat, no-flip repeat, and fold over.

22) Rotate field

Input a value in this field to rotate a tone as you wish. You can input any value from - 360 degrees to 360 degrees in increments of 0.1 degrees. Inputting a value greater than 360 will result in the difference between that value and 360 being input. To enter the value after you input it, hit the Enter key or click anywhere on the tone. Hitting the Enter key twice will close the Tone window, so be careful.

23) Rotate Slide

You can also set a rotation angle by dragging the Angle Slide. The slide can move from -358 degrees to 358 degrees, in two-degree increments. The center, extreme left, and extreme right of the slide bar are set to zero degrees.

24) Magnification Ratio field

Entering a value in this field sets the magnification factor of your display. You can enter any value from 10% to 1000% in increments of 0.1%. To enter the value after you input it, hit the Enter key or click anywhere on the tone. Hitting the Enter key twice will close the Tone window, so be careful.

25) Magnification Ratio Slide

You can also set a magnification ratio by dragging the Magnification Ratio Slide. The slide can move from 10% magnification to 1000%, in 0.1% increments. The center of the slide bar is set to 100%. If you have specified a Tone Draw Area, then when you drag this slide the area will turn either white or gray, and the rest of the image will turn pink. To close the Magnification Ratio Slide, click anywhere outside the slide.

26) Density field

This field is only for grayscale tones. Entering a value in this field sets the density of a tone. You can enter any value from 20% to 180% in increments of 0.1%. To enter the value after you input it, hit the Enter key or click anywhere on the tone. Hitting the Enter key twice will close the Tone window, so be careful.

27) Density Slide

This field is only for grayscale tones. You can also set the density by dragging the Density Slide. The slide can move from 20% density to 180%, in 0.5% increments. The center of the slide bar is set to 100%. To close the Density Slide, click anywhere outside the slide.

28) Expression field

This field is only for grayscale tones. The choices of expression are None, Dots, Line, Cross, and Random. Choosing "None" will apply no dot shading.

29) LPI field

This field is only for grayscale tones; enter a lines per inch (LPI) value here as you like to apply dot shading. You can enter values from 1 to 85 in 0.1 increments. To enter the value after you input it, hit the Enter key or click anywhere on the tone. Hitting the Enter key twice will close the Tone window, so be careful. If you want to avoid "tone jumping," then you should specify 20 LPI for an image at 300 dpi or less, and 40 LPI for an image at 600 dpi or less.

- You must have something other than "none" selected in the Expression field in order to use this.

30) LPI Input button

This field is only for grayscale tones. You can specify the LPI value for applying dot shading to your selected grayscale tone at an angle of your choosing. Each click of the button steps through from 20 LPI to 27.5, 32.5, 42.5, 50, 55, 60, 65, 70, 75, to 80 LPI, displaying your image appropriately at each step. If you want to avoid "tone jumping," then you should specify 20 LPI for an image at 300 dpi or less, and 40 LPI for an image at 600 dpi or less.

- You must have something other than "none" selected in the Expression field in order to use this.

31) Angle field

This one is for grayscale tones only. You can specify the LPI value for applying dot shading to your selected grayscale tone at an angle of your choosing. You can input any value from -360 degrees to 360 degrees in increments of 0.1 degrees. We recommend that you normally use a 45-degree setting. To enter the value after you input it, hit the Enter key or click anywhere on the tone. Hitting the Enter key twice will close the Tone window, so be careful.

- You must have something other than "none" selected in the Expression field in order to use this one.

32) Angle adjustment buttons

These buttons are for grayscale tones only. By manipulating the upper and lower buttons, you can specify an angle as you like to apply dot shading. Each click of the button steps through from 0 degrees to 15, 30, 45, 60, 75, 90, 105, 120, 135, 150, and 165 degrees, displaying your image appropriately at each step. You will not be able to set this angle if you have "random" selected in the Expression field.

- You must have something other than "none" selected in the Expression field in order to use this one.

33) OK button

Hitting this button will set the tone and any modifications you have made onto your image, and return you to your graphic application. The parameters you set while using Tone will be remembered, and the next time you start it up they will be as you left them.

34) Cancel button

Hitting this button will cancel setting the tone and any modifications you have made onto your image, and return you to your graphic application. The parameters you set while using Tone will be remembered, and the next time you start it up they will be as you left them.

35) Clear Settings button

Pushing this button will reset any values you have changed to their defaults, which are as follows.
- Paste Method: Repeat, Angle: 0 degrees, Magnification: 100%, Density: 100%, Expression: Dot, LPI: 60, Angle: 45 degrees.

36) Tone Set Selection pull-down menu

This changes the tone set you wish to use. Click on this menu and select a tone set from those displayed. Then, by moving on to choose a tone set from among those in the tone set display, you can display its contents on your screen. A maximum of 20 sets within a single tone set can be displayed

- There may not be any tone set selections displayed in this field. In that case, proceed as follows:

 1. Create a new tone set by hitting the Menu button and using the "New Tone Set..." command.
 2. Import a tone set by hitting the Menu button, selecting Import Tone Set File, and saving a tone set as you wish..

37) Tone Information Display

When you select a tone from within the tone set display, a variety of information about that tone is displayed. In the Tone Information Display, from left to right, you will find the tone set index number, title, LPI, density, and size of the tone. Further, a "---" is displayed where no information is available or there is no need to display anything.

*About the tone information headings

The tone set index number is a number attached to every tone and displayed next to it in the tone set display. The numbers run from the top left tone across to the right and down, counting off each tone.

The title indicates some characteristic of a tone.

The LPI value shows how many lines of dots per inch make up a tone. For the most part, other than dot and line screens, most tones do not have this information, so nothing is displayed. Sand tones have an LPI value, but this is approximate.

Density is expressed as a percentage for each tone. A perfectly white tone has a 0% density, while a perfectly black one has 100%. A display of "100-0%" or "100-0-100%" means a given tone is a gradation.

Size is the length by width dimensions of a tone in centimeters. Tones with only a single value displayed are pattern tones with no boundary on either their width or length.

1 ———————————— Tone's Code No.

———————————— Tone's Image

20.0Line(s) ———————————— Lines Per Inch (PLI)

10% ———————————— Density

--- ———————————— Size

38) Menu button
Pressing this button brings up the Menu.

Supplement: Tone Set Registration and Building
If you did not check the "Also copy tone files" box at installation, the necessary tone files will not be on your local disk, meaning you cannot automatically register a tone set. The steps for manually registering and building a tone set are shown below.

```
❶  New Tone Set...

❷  Rename Tone Set...
❸  Delete Tone Set...

❹  Import Tone Set File      ▶
❺  Add Tone File Folder...

❻  Display Name
❼  ✓ Display Number
❽  ✓ Display LPI
❾  ✓ Display Density
❿  ✓ Display Size
```

❶ New Tone Set...
This command creates a new tone set on your local disk. You can use this command by selecting it from the tone set selection field, and you can create up to 1000 tone sets. When you use this command, a dialog box will appear, asking you to name your tone set. Once you've given it a name you like, click on OK to create a tone set. Click on the Cancel button to cancel the command.

❷ Rename Tone Set...
This command changes the name of the current tone set. Using it makes a dialog box appear asking you for a new tone set name. After you have entered a name you like, click on the OK button and the name will be changed. If you want to cancel the name change, hit the Cancel button.

❸ Delete Tone Set...

This command deletes the current tone set. However, the tones themselves will not be deleted and will remain on your local disk. Using this command will bring up a confirmation dialog box. If you wish to delete the tone set, click on Yes. If you do not, click on No.

❹ Import Tone Set File

This command imports a new tone set you would like to use and adds it behind the current tone set. Using this command brings up a submenu—click on View File. Another dialog box will appear to ask you where the next tone set you would like to import is located. Click on a tone set file (extension ".tst") and click on Open. If you want to cancel the import, click on Cancel. If you click on the list of previously added tone set files, you can choose a set from there as well.

- If you do not want to put the tone set you wish to import inside the tone set you are currently using, first use the Create New Tone Set command from the Menu to create a new set, and then import your desired tone set file to there.

❺ Add Tone File Folder...

Use this command to add all the tones in a folder you specify to the end of the current tone set in one stroke. Executing this command brings up a dialog box asking you for the location of the tone file folder. Choose the folder you wish and click on the OK button. If you wish to cancel the command, click on Cancel. Folders located inside the folder you specify can also be searched.

- **Add Tone File...**
 This command adds a single tone file to the end of the current tone set. Using this

command brings up a dialog box asking you for the location of the tone file you wish to add. Choose the ".tdt" file you wish and click on Open. If you wish to cancel the command, click on Cancel.

❻ Display Name
Using this command switches between displaying all tone names and displaying all tone thumbnails.

❼ Display Number
Using this command switches the display of all visible tone numbers on and off.

❽ Display LPI
Using this command switches the display of all visible tone LPI values on and off.

❾ Display Density
Using this command switches the display of all visible tone density values on and off.

❿ Display Size
Using this command switches the display of all visible tone sizes on and off.

Tone Set Display

This command displays the contents of the selected tone set at a glance. A total of 1200 tones, 6 across and 200 down, can be displayed at once. You can execute the following actions on a single tone therein:

Click: The selected tone is applied to the Tone Draw Area.

Double Click: Same effect as hitting the OK button after the selected tone is applied.

Ctrl + Drag: Moves the selected tone as you wish.

Selecting a Tone: Displays the tone's information in the tone information display area. This area will appear blank if the display area is not open.

Right Click: Opens up an embedded smaller menu with the following commands.

Add Tone File...

This command inserts a tone directly before the selected one. Using this command brings up a dialog box asking you for the location of the tone file you wish to add. Choose the ".tdt" file you wish and click on Open. If you wish to cancel the command, click on Cancel. Using this command to add a tone will shift all the following tone files' numbers, so care must be taken when importing tone palette files and the like.

Add White Space

This command inserts or adds a blank space after the selected tone set. Clicking on a blank allows you to reset the currently applied tone.

Select All

This command selects all of the tones loaded into the tone display area.

Insert White Space

This command inserts or adds a blank space directly in front of the selected tone. Clicking on a blank allows you to reset the currently applied tone. Using this command to add a tone will shift all the following tone files' numbers, so care must therefore be taken when importing tone palette files and the like.

Remove

Using this command removes only the selected tone from the tone set. The tone itself is not deleted from your local disk.

File Info...

Using this command displays a tone's full path in a new window. Click on OK to close it.

Using Shortcut Keys

Shortcut key combinations are available for the commands listed below.

Tone Shortcuts:
Spacebar → Hand Tool
Alt → Zoom Out
Ctrl → Zoom In
Alt + Spacebar → Rotate
Ctrl + Spacebar → Scale
Alt + Ctrl → Move
Alt + Ctrl + Space → Pin

Ctrl Shift Alt Space

Error Message Overview

The various Computones error messages are listed below. Should any others occur, as they are related to your operating system and/or graphic software, please consult the appropriate manual for a solution.

Error: Insufficient memory.
Cause: The PC does not have enough memory to run Computones
Solution: Shut down any other open applications or clear the internal memory in use by another graphic application to free up system memory and reserve it. (For more details, please see your graphic software manual.) If after this you still do not have enough memory, then you must increase the amount of physical system memory. The more internal system memory you have, the smoother Computones will operate.

Error: Incorrect serial number.
Cause: The serial number has not been input correctly.
Solution: You will only be asked once for the serial number. Check the number at the end of this book, make sure you have entered it correctly, and click on the OK button.

Error: Not a tone file.
Cause: You have specified a non-tone file for import.
Solution: Select a Computones-compatible tone file (.tdt).

Error: Not a tone set file.
Cause: You have specified a non-tone set file for import.
Solution: Select a Computones-compatible tone set file (.tst).

Error: Too many items. Cannot add to the tone set.
Cause: You are trying to add over 1002 tones to a single tone set.
Solution: A single tone set can hold a maximum of 1002 tones. To set or add more tones, use Menu → Create New Tone Set...

Error: An error has occurred.

Cause: Something other than the above has caused an error.

Solution: Make sure you are using a Computones-compatible environment. Reboot your computer and attempt to continue. If the same error appears, try reserving system memory. If problems still persist, then uninstall Computones and try reinstalling it. If even after that you still get the same error, then there is probably some issue with your operating system.

Error: An "X" is displayed in place of a tone file in a tone set, as shown in figure 1.

Cause: A tone file that is specified within the tone set cannot be found. The file itself is not present, and only the file path has been retained. If the CD-ROM drive or the local disk label has changed, or if there has been some other change in the computing environment, then this problem can occur.

Solution: Take the following steps. Select the tone in question, and then click on the following, in order: Menu → Delete Tone Set... → Yes → Create New Tone Set... → Input new tone set name → Import Tone Set File... → Browse Files... → Choose a tone set file → Open.

When the tone set is displayed as in figure 2 at the right, then the process is complete.

Question & Answer

Q How do I install Computones for Photoshop Elements 2?

A To install Computones for Adobe Photoshop Elements 2.0, follow the steps shown below.

1. Insert the Computones CD-ROM into a CD-ROM or DVD-ROM drive.

2. Double-click on the My Computer icon on the Windows desktop (Windows XP users should click on the Start Menu and then click on My Computer), and double-click on the Computones CD-ROM icon → Computones Installer.exe (or simply "Computones Installer").

3. You will be asked to which folder or directory you want to install Computones. Check the "Browse for plug-in file install location" radio button.

4. Choose a tone file install method, and click Install. A "Browse for Folder" dialog box will appear, allowing you to select the plug-in file install location. Click on the Local Disk (C:) → Program Files → Adobe → Photoshop Elements 2 → Plug-Ins. When you have selected the folder, click OK. If you have installed Photoshop Elements 2 to some other location, then select the Plug-Ins folder accordingly.

5. A "Confirm the installation directory" dialog box will appear. Check the file install location and click Yes to continue. If there is something wrong with the location, click No and repeat this process from step 3.

6. If you have checked the "Also copy tone files" box, then a "Browse for Folder" dialog box will appear. Add or remove tone files as you see fit, and click OK.

Once all installations are complete, an "Installation complete" dialog will appear. If the installation failed, repeat this process from step 2.

Q I cannot select any files to install, so I cannot install Computones!

A If during the Computones installation, the "Select installation files" dialog box has nothing displayed in the "Files to be installed" and "Files on the CD" lists, and you cannot continue with the installation, follow the steps shown below.

1. Insert the Computones CD-ROM into a CD-ROM or DVD-ROM drive.

2. Double-click on the My Computer icon on the Windows desktop (Windows XP users should click on the Start Menu and then click on My Computer), and double-click on the Computones CD-ROM icon → Computones Installer.exe (or simply "Computones Installer").

3. You will be asked to which folder or directory you want to install Computones. Check whichever radio button you like, uncheck "Also copy tone files," and click the Install button.

4. A "Confirm the installation directory" dialog box will appear. Check the file install location and click Yes to continue. If there is something wrong with the location, click No and repeat this process from step 3.

At this point the Computones plug-in and utility file installation is complete.

5. Next, install the tone files. Open up the Computones folder at its install location, create a new folder, and rename it "ToneFolder." You can verify the folder's install location in step 4 via the "Confirm the installation directory" dialog box.

6. Select the CTHDM01 folder on the Computones CD-ROM and choose one of the following methods to copy it to the Computones folder on your local disk.

 ❶ Right click on the CTHDM01 folder, and click on Copy from the pop up menu. Then right click on any blank space inside the Computones folder on your local disk and choose Paste.
 ❷ Drag the tone folders from the CD-ROM and drop them on some empty space inside Computones folder on your local disk.

7. The tone file installation is now complete. Next, start up Tones, click the Menu button, select Import Tone Set File → View File..., and import the tone file sets you just installed. If you copied tone set files that you do not need, use one of the methods below to remove them.

 ❶ If there are tones at certain resolutions you do not need, then put the entire 300 dpi or 600 dpi folders in the Recycle Bin to remove them.
 ❷ If there are certain tone genres you do not need, then open each resolution folder and place the Dot, Hatching, etc. folders in the Recycle Bin to remove them. Also remove tone set files like PT3-600-ALL.tst. that contain tones of all genres.

Q A "Cannot find the tone folder" message appears, and I cannot install Computones!

A If during the Computones installation, a "Cannot find the tone folder" message appears, and you cannot continue with the installation, follow the steps shown below.

1. Insert the Computones CD-ROM into a CD-ROM or DVD-ROM drive.

2. Double-click on the My Computer icon on the Windows desktop (Windows XP users should click on the Start Menu and then click on My Computer), and double-click on the Computones CD-ROM icon → Computones Installer.exe (or simply "Computones Installer").

Question & Answer

3. You will be asked to which folder or directory you want to install Computones. Check whichever radio button you like, uncheck "Also copy tone files," and click the Install button.

4. A "Confirm the installation directory" dialog box will appear. Check the file install location and click Yes to continue. If there is something wrong with the location, click No and repeat this process from step 3.

At this point the Computones plug-in and utility file installation is complete.

5. Next, install the tone files. Open up the Computones folder at its install location, create a new folder, and rename it "ToneFolder." You can verify the folder's install location in step 4 via the "Confirm the installation directory" dialog box.

6. Select the CTHDM01 folder on the Computones CD-ROM and choose one of the following methods to copy it to the Computones folder on your local disk.

 ❶ Right click on the CTHDM01 folder, and click on Copy from the pop up menu. Then right click on any blank space inside the Computones folder on your local disk and choose Paste.
 ❷ Drag the tone folders from the CD-ROM and drop them on some empty space inside Computones folder on your local disk.

7. The tone file installation is now complete. Next, start up Tones, click the Menu button, select Import Tone Set File → View File..., and import the tone file sets you just installed. If you copied tone set files that you do not need, use one of the methods below to remove them.

 ❶ If there are tones at certain resolutions you do not need, then put the entire 300 dpi or 600 dpi folders in the Recycle Bin to remove them.
 ❷ If there are certain tone genres you do not need, then open each resolution folder and place the Dot, Hatching, etc. folders in the Recycle Bin to remove them.

Q A "Computones may not have been installed" message appears, and I cannot install Computones!

A If during the Computones installation, a "The main Computones application may not have been installed" message appears, and you cannot continue with the installation, follow the steps shown below.

1. Insert the Computones CD-ROM into a CD-ROM or DVD-ROM drive.

2. Double-click on the My Computer icon on the Windows desktop (Windows XP users should click on the Start Menu and then click on My Computer). Next, open the Plug-In folder for

whichever application to which you want to install Computones. If you have installed these folders to their default locations, they will be located as follows. The actual plug-in folder names may vary according to software package and version.

Adobe Photoshop 5.0/5.5/6.0/7.0/CS:
　C:/Program Files/Adobe/Photoshop 5.0/Plug-ins
　C:/Program Files/Adobe/Photoshop 5.5/Plug-ins
　C:/Program Files/Adobe/Photoshop 6.0/Plug-ins
　C:/Program Files/Adobe/Photoshop 7.0/Plug-ins
　C:/Program Files/Adobe/Photoshop CS/Plug-ins

Adobe Photoshop Elements 1.0/2.0:
　C:/Program Files/Adobe/Photoshop Elements/Plug-ins
　C:/Program Files/Adobe/Photoshop Elements 2.0/Plug-ins

Jasc Paint Shop Pro 7/8:
　C:/Program Files/Jasc Software Inc/ Paint Shop Pro 7/Plugins
　C:/Program Files/Jasc Software Inc/ Paint Shop Pro 8/Plugins

If you have changed the default installation directories for these applications, then the Plug-In folders will not be located as above.

3. Open up the Plug-Ins folder, create a new folder in it, and rename it "Computones." Open that folder, and create two new folders inside it. Rename one "Computones" and the other "ToneFolder."

4. Open the PlugIn folder on the Computones CD-ROM, select the screentone.8bf file, and drop it into the Computones folder on the local disk.

5. Select the Computones folder on the Computones CD-ROM, and drop it into the ToneFolder folder. The tone file installation is now complete. Next, after starting Photoshop or whichever application you are using, start up Computones → Tones or Multi Tones, click on the Menu button, select Import Tone Set File → View File..., and import the tone file sets you just installed. If you copied tone set files that you do not need, use one of the methods below to remove them.

❶ If there are tones at certain resolutions you do not need, then put the entire 300 dpi or 600 dpi folders in the Recycle Bin to remove them.

❷ If there are certain tone genres you do not need, then open each resolution folder and place the Dot, Hatching, etc. folders in the Recycle Bin to remove them.

Question & Answer

Q I tried running the uninstaller, but I cannot remove Computones!

A If you used a drag-and-drop or copy-and-paste method to install Computones from the CD-ROM, then the ComputonesUninstaller.exe (or "Computones Uninstaller") may not work. In that case, follow the steps below.

1. Double-click on the My Computer icon on the Windows desktop (Windows XP users should click on the Start Menu and then click on My Computer). Next, open the Plug-In folder for whichever application from which you want to uninstall Computones. If you have installed these folders to their default locations, they will be located as follows. The actual folder names may vary according to software package and version.

 Adobe Photoshop 5.0/5.5/6.0/7.0/CS:
 C:/Program Files/Adobe/Photoshop 5.0/Plug-ins
 C:/Program Files/Adobe/Photoshop 5.5/Plug-ins
 C:/Program Files/Adobe/Photoshop 6.0/Plug-ins
 C:/Program Files/Adobe/Photoshop 7.0/Plug-ins
 C:/Program Files/Adobe/Photoshop CS/Plug-ins

 Adobe Photoshop Elements 1.0/2.0:
 C:/Program Files/Adobe/Photoshop Elements/Plug-ins
 C:/Program Files/Adobe/Photoshop Elements 2.0/Plug-ins

 Jasc Paint Shop Pro 7/8:
 C:/Program Files/Jasc Software Inc/ Paint Shop Pro 7/Plugins
 C:/Program Files/Jasc Software Inc/ Paint Shop Pro 8/Plugins

 If you have changed the default installation directories for these applications, then the Plug-In folders will not be located as above.

2. Select the Computones folder in your application's Plug-In folder and drag-and-drop it into the Recycle Bin, or right click on the folder and select Delete from the pop up menu. To completely remove the Computones folder, open the Recycle Bin, and select Empty Recycle Bin from the File menu, or right click on the Recycle Bin and select Empty Recycle Bin from the pop up menu.

Q When I apply a duotone to my image, it looks blurry!

A When you apply a duotone to an image and then display it at 66.6%, 33.3%, or any other magnification other than 100%, it can appear blurry or appear to be "tone jumping." This is due to Photoshop's image interpolation, and there is no actual blurriness present. If you wish to confirm this via your display, be sure to set your magnification factor to 100%.

Q When I print anything out on an inkjet printer, it looks blurry!

A The way inkjet printers print things, it is not possible to print dot patterns precisely as they appear. Also, it may be that the output resolution of the printer you are using and the resolution of the tones in your image are not compatible. This can cause significant blurring or tone jumping. In order to print clearly on an inkjet printer, you must adequately adjust the resolution settings of both the printer and your image.

Q What should I do to print clearly on an inkjet printer?

A If the resolution of the printer you are using and the resolution of the tones in your image are not compatible, blurring or tone jumping can occur. The way inkjet printers print things, it is not possible to print dot patterns precisely as they appear, but by adjusting the output resolution of your printer and the resolution of your image, you can improve print quality and bring it closer to your original work.

1. Verify the output resolution of your printer in your manual.

2. Open your original image in Photoshop. Create multiple working copies of your work for printing purposes.

3. Select Image → Image Size and an Image Size dialog box will appear. Check the Resolution value in the Document Size area. If one of the following conditions applies, proceed to step 4.

 *the inkjet printer resolution = the image resolution
 *the inkjet printer resolution = an even multiple of the image resolution
 *an even multiple of the inkjet printer resolution = the image resolution

If the above conditions do not apply, then your inkjet printer will interpolate the image according to its driver, and the blurriness and tone jumping in your printed image will be worse. In this case, check the Constrain Proportion and Resample Image boxes in the Image Size dialog box, and choose Nearest Neighbor from the Resample Image pull-down menu. Set the Resolution in the Document Size area to match your printer. If your printer's resolution is 1200 dpi or higher, then enter the printer resolution divided by 2 or 4.

4. Click the OK button to apply the current resolution settings, select File → Print..., and print the image. If there is a "Bidirectional Printing" option in your Print dialog, turn it off and then print your image. Leaving this option on may cause tone jumping.

Tone Collection Guide

Dot Tones

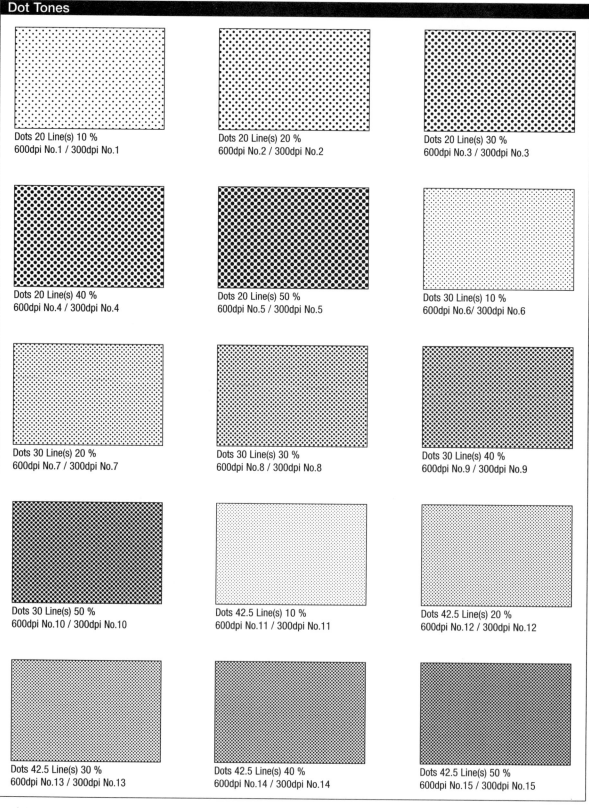

Dots 20 Line(s) 10 %
600dpi No.1 / 300dpi No.1

Dots 20 Line(s) 20 %
600dpi No.2 / 300dpi No.2

Dots 20 Line(s) 30 %
600dpi No.3 / 300dpi No.3

Dots 20 Line(s) 40 %
600dpi No.4 / 300dpi No.4

Dots 20 Line(s) 50 %
600dpi No.5 / 300dpi No.5

Dots 30 Line(s) 10 %
600dpi No.6/ 300dpi No.6

Dots 30 Line(s) 20 %
600dpi No.7 / 300dpi No.7

Dots 30 Line(s) 30 %
600dpi No.8 / 300dpi No.8

Dots 30 Line(s) 40 %
600dpi No.9 / 300dpi No.9

Dots 30 Line(s) 50 %
600dpi No.10 / 300dpi No.10

Dots 42.5 Line(s) 10 %
600dpi No.11 / 300dpi No.11

Dots 42.5 Line(s) 20 %
600dpi No.12 / 300dpi No.12

Dots 42.5 Line(s) 30 %
600dpi No.13 / 300dpi No.13

Dots 42.5 Line(s) 40 %
600dpi No.14 / 300dpi No.14

Dots 42.5 Line(s) 50 %
600dpi No.15 / 300dpi No.15

Dot Tones

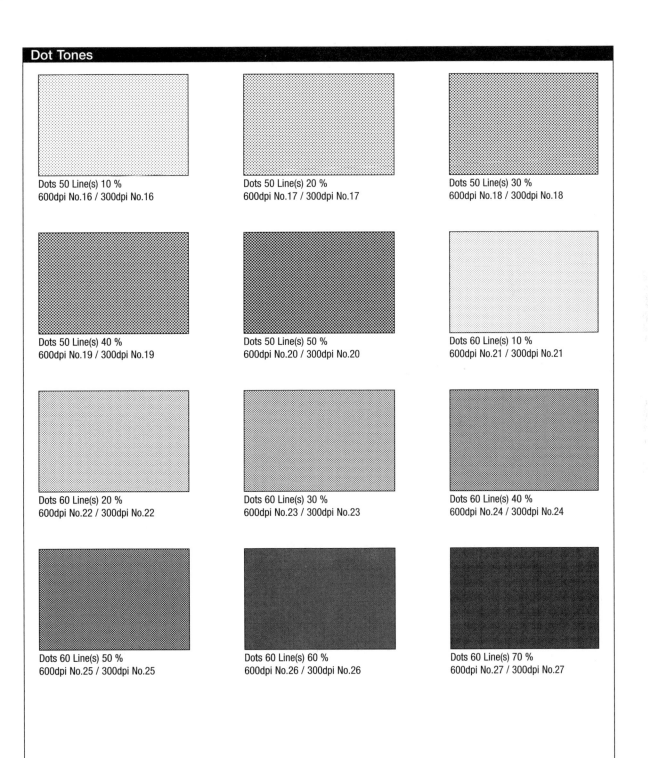

Dots 50 Line(s) 10 %
600dpi No.16 / 300dpi No.16

Dots 50 Line(s) 20 %
600dpi No.17 / 300dpi No.17

Dots 50 Line(s) 30 %
600dpi No.18 / 300dpi No.18

Dots 50 Line(s) 40 %
600dpi No.19 / 300dpi No.19

Dots 50 Line(s) 50 %
600dpi No.20 / 300dpi No.20

Dots 60 Line(s) 10 %
600dpi No.21 / 300dpi No.21

Dots 60 Line(s) 20 %
600dpi No.22 / 300dpi No.22

Dots 60 Line(s) 30 %
600dpi No.23 / 300dpi No.23

Dots 60 Line(s) 40 %
600dpi No.24 / 300dpi No.24

Dots 60 Line(s) 50 %
600dpi No.25 / 300dpi No.25

Dots 60 Line(s) 60 %
600dpi No.26 / 300dpi No.26

Dots 60 Line(s) 70 %
600dpi No.27 / 300dpi No.27

Tone Collection Guide

Line Tones

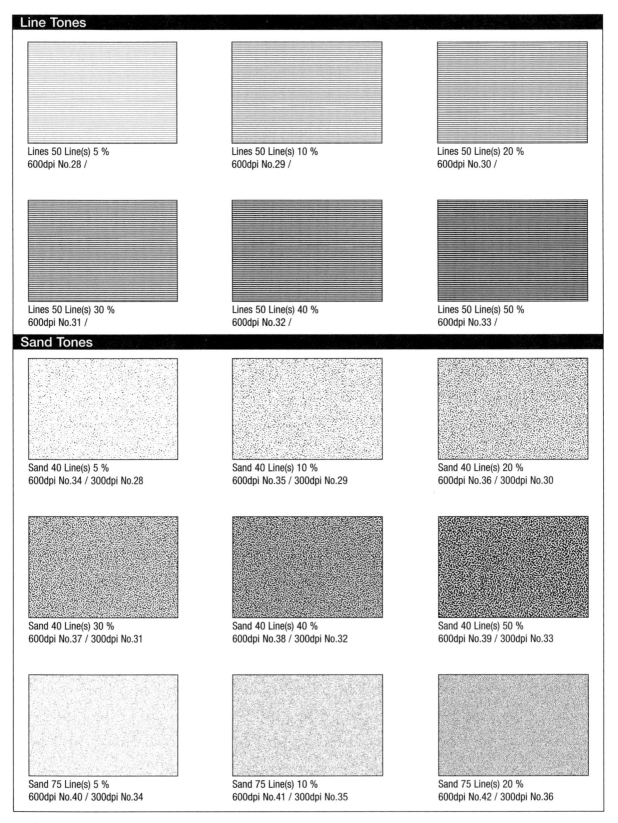

Lines 50 Line(s) 5 %
600dpi No.28 /

Lines 50 Line(s) 10 %
600dpi No.29 /

Lines 50 Line(s) 20 %
600dpi No.30 /

Lines 50 Line(s) 30 %
600dpi No.31 /

Lines 50 Line(s) 40 %
600dpi No.32 /

Lines 50 Line(s) 50 %
600dpi No.33 /

Sand Tones

Sand 40 Line(s) 5 %
600dpi No.34 / 300dpi No.28

Sand 40 Line(s) 10 %
600dpi No.35 / 300dpi No.29

Sand 40 Line(s) 20 %
600dpi No.36 / 300dpi No.30

Sand 40 Line(s) 30 %
600dpi No.37 / 300dpi No.31

Sand 40 Line(s) 40 %
600dpi No.38 / 300dpi No.32

Sand 40 Line(s) 50 %
600dpi No.39 / 300dpi No.33

Sand 75 Line(s) 5 %
600dpi No.40 / 300dpi No.34

Sand 75 Line(s) 10 %
600dpi No.41 / 300dpi No.35

Sand 75 Line(s) 20 %
600dpi No.42 / 300dpi No.36

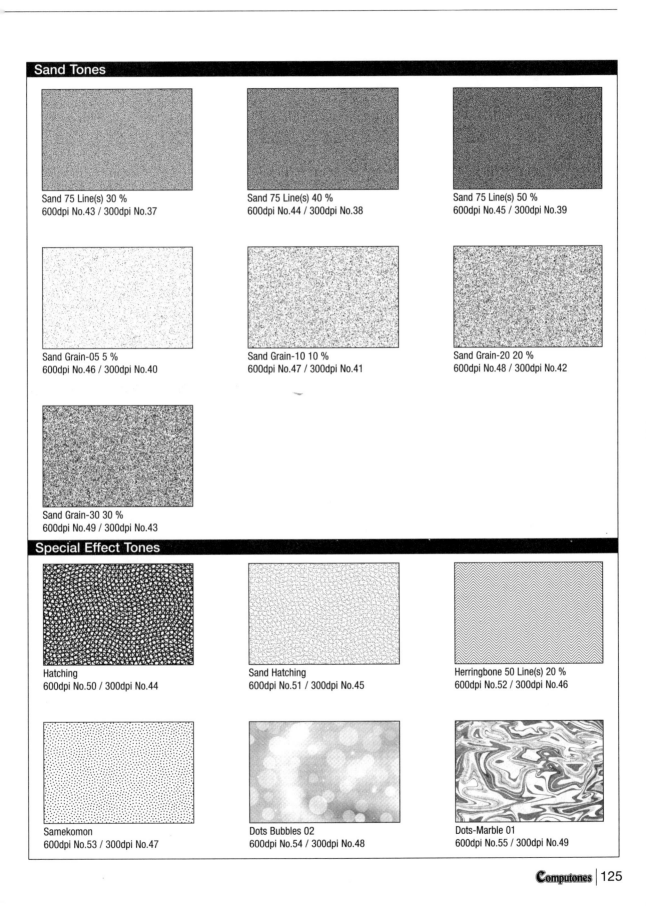

Sand Tones

Sand 75 Line(s) 30 %
600dpi No.43 / 300dpi No.37

Sand 75 Line(s) 40 %
600dpi No.44 / 300dpi No.38

Sand 75 Line(s) 50 %
600dpi No.45 / 300dpi No.39

Sand Grain-05 5 %
600dpi No.46 / 300dpi No.40

Sand Grain-10 10 %
600dpi No.47 / 300dpi No.41

Sand Grain-20 20 %
600dpi No.48 / 300dpi No.42

Sand Grain-30 30 %
600dpi No.49 / 300dpi No.43

Special Effect Tones

Hatching
600dpi No.50 / 300dpi No.44

Sand Hatching
600dpi No.51 / 300dpi No.45

Herringbone 50 Line(s) 20 %
600dpi No.52 / 300dpi No.46

Samekomon
600dpi No.53 / 300dpi No.47

Dots Bubbles 02
600dpi No.54 / 300dpi No.48

Dots-Marble 01
600dpi No.55 / 300dpi No.49

Tone Collection Guide

Lightning
600dpi No.56 / 300dpi No.50

Stipple Bubbles
600dpi No.57 / 300dpi No.51

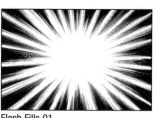

Flash Fills 01
600dpi No.58 / 300dpi No.52

Flash Fills 02
600dpi No.59 / 300dpi No.53

Rendering Lines 01
600dpi No.60 / 300dpi No.54

Rendering Lines 02
600dpi No.61 / 300dpi No.55

Rendering Lines 03
600dpi No.62 / 300dpi No.56

Rendering Lines 04
600dpi No.63 / 300dpi No.57

Rendering Lines 05
600dpi No.64 / 300dpi No.58

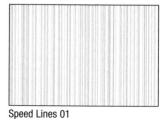

Speed Lines 01
600dpi No.65 / 300dpi No.59

Speed Lines 02
600dpi No.66 / 300dpi No.60

Speed Lines 03
600dpi No.67 / 300dpi No.61

Gradations

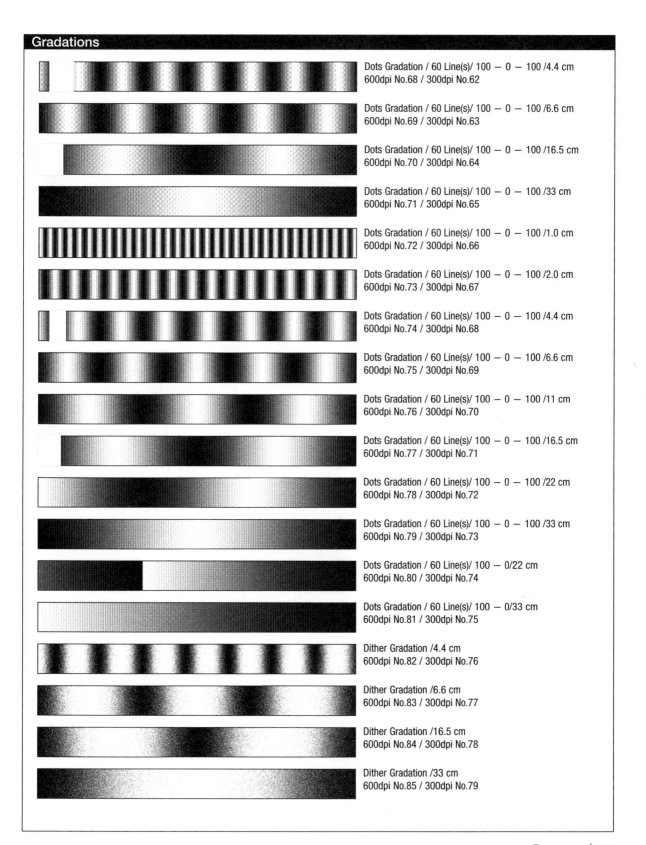

Dots Gradation / 60 Line(s)/ 100 — 0 — 100 /4.4 cm
600dpi No.68 / 300dpi No.62

Dots Gradation / 60 Line(s)/ 100 — 0 — 100 /6.6 cm
600dpi No.69 / 300dpi No.63

Dots Gradation / 60 Line(s)/ 100 — 0 — 100 /16.5 cm
600dpi No.70 / 300dpi No.64

Dots Gradation / 60 Line(s)/ 100 — 0 — 100 /33 cm
600dpi No.71 / 300dpi No.65

Dots Gradation / 60 Line(s)/ 100 — 0 — 100 /1.0 cm
600dpi No.72 / 300dpi No.66

Dots Gradation / 60 Line(s)/ 100 — 0 — 100 /2.0 cm
600dpi No.73 / 300dpi No.67

Dots Gradation / 60 Line(s)/ 100 — 0 — 100 /4.4 cm
600dpi No.74 / 300dpi No.68

Dots Gradation / 60 Line(s)/ 100 — 0 — 100 /6.6 cm
600dpi No.75 / 300dpi No.69

Dots Gradation / 60 Line(s)/ 100 — 0 — 100 /11 cm
600dpi No.76 / 300dpi No.70

Dots Gradation / 60 Line(s)/ 100 — 0 — 100 /16.5 cm
600dpi No.77 / 300dpi No.71

Dots Gradation / 60 Line(s)/ 100 — 0 — 100 /22 cm
600dpi No.78 / 300dpi No.72

Dots Gradation / 60 Line(s)/ 100 — 0 — 100 /33 cm
600dpi No.79 / 300dpi No.73

Dots Gradation / 60 Line(s)/ 100 — 0/22 cm
600dpi No.80 / 300dpi No.74

Dots Gradation / 60 Line(s)/ 100 — 0/33 cm
600dpi No.81 / 300dpi No.75

Dither Gradation /4.4 cm
600dpi No.82 / 300dpi No.76

Dither Gradation /6.6 cm
600dpi No.83 / 300dpi No.77

Dither Gradation /16.5 cm
600dpi No.84 / 300dpi No.78

Dither Gradation /33 cm
600dpi No.85 / 300dpi No.79

Tone Collection Guide

Sand Hatching Floral
600dpi No.86 / 300dpi No.80

Dots Floral
600dpi No.87 / 300dpi No.81

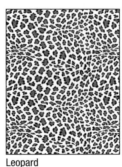

Checker
600dpi No.88 / 300dpi No.82

Dots 5 Line(s) 10 %
600dpi No.89 / 300dpi No.83

Dots 15 Line(s) 10 %
600dpi No.90 / 300dpi No.84

Dots 15 Line(s) 30 %
600dpi No.91 / 300dpi No.85

Stars
600dpi No.92 / 300dpi No.86

Grayscal

Floral Pattern
600dpi No.1 / 300dpi No.1

Flames
600dpi No.2 / 300dpi No.2

Fire
600dpi No.3 / 300dpi No.3

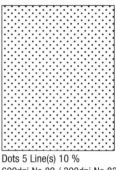

Parallel Lines 01
600dpi No.4 / 300dpi No.4

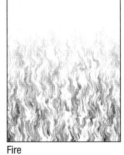

Parallel Lines 02
600dpi No. 5 / 300dpi No.5

Parallel Beams
600dpi No.6 / 300dpi No.6

Leopard
600dpi No.8 / 300dpi No.8

Camo
600dpi No.9 / 300dpi No.9